W9-ACX-211

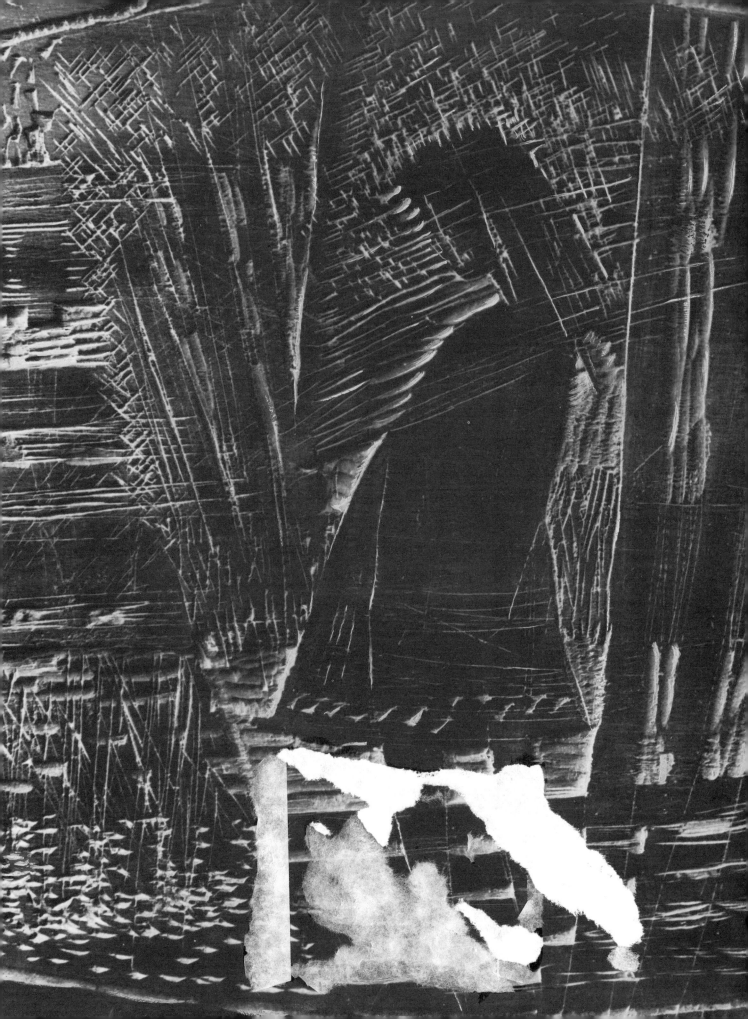

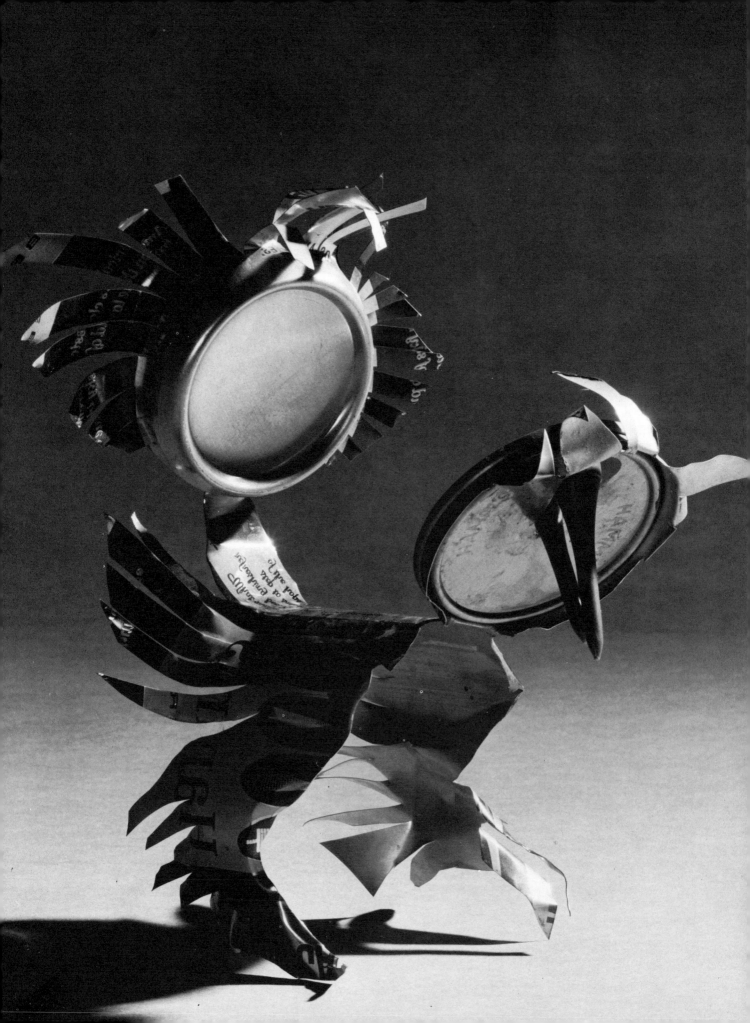

art from scrap

Carl Reed
Co-ordinator, MAT in Art Education
University of Massachusetts

Joseph Orze
Dean, College of Fine Arts
Southeastern Massachusetts University

Davis Publications, Inc. Worcester, Massachusetts

Frontispiece —

"A Fighting Cock" by Harry Wood. One aluminum can cut with ordinary household scissors and shaped. The beak is made with two golf tees.

"The Humpo River" by Brita. A discarded drawing board was used as a block to make this wood cut. The illustrations on the end papers of this book show the details of the wood cut and the print. The artist took advantage of the grain in the wood and the many blade cuts that had been made when the board was being used for mat cutting. A discarded drawing board turned into a medium for creating a work of art!

Copyright 1960 and 1974
Davis Publications, Inc.
Worcester, Massachusetts, U.S.A.

All rights reserved.
Library of Congress Catalog Card Number: 73-87725
ISBN: 0-87192-055-7
Printing: Davis Press
Design: Thumbnail Associates

10 9 8 7 6 5 4 3 2 1

Acknowledgments

The authors are grateful to: 1) the many young artists — pre-school, primary, middle, and high school — whose works are shown here; 2) the numerous art teachers who submitted examples of the work of their students for consideration and selection; and 3) those professional adults, whose works demonstrate that scrap materials can be converted into exhibition art. Without the cooperation of all the aforementioned people this revision of *Art from Scrap* could not have been accomplished.

contents

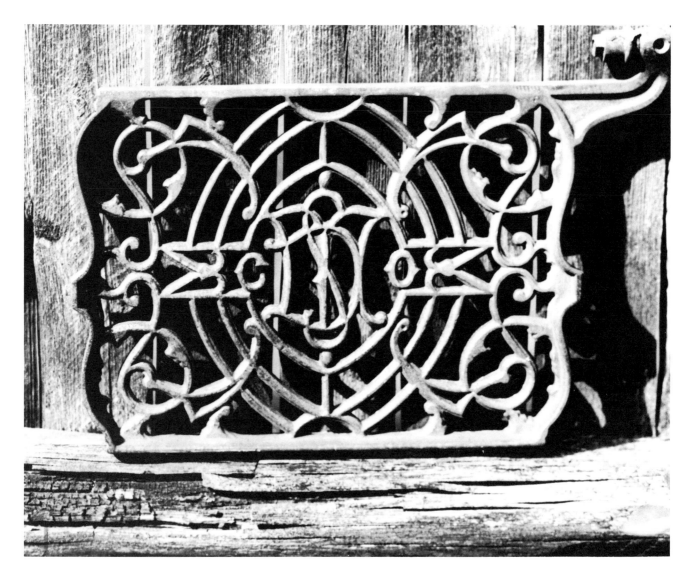

Many found objects are beautiful in their own right and can be used as decorative ornaments, without alteration or combination with other materials. This attractive cast iron piece once must have been part of a stove. The manufacturer's monogram is placed in the center of the swirling iron pattern, becoming a part of the design. It is now used as a decorative spot on a patio. The object was rescued from a dump in Wisconsin.

introduction

It is the intention of the authors that this book provide for students and teachers: 1) illustrative material that may stimulate exploration in a broad range of creative expressions, 2) some suggestions which may inspire the use of various scrap materials, in both two- and three-dimensional art projects, 3) possible alternatives from the manner in which scrap materials may have been used previously, and 4) some information related to tools, materials, processes, and techniques which may aid the student in creative activity.

Art from Scrap was first published more than ten years ago and has been reprinted six times. Originally the book was motivated by the many art teachers and grade teachers who sought help in their attempts to conduct meaningful art programs on a very limited budget. These requests for assistance encouraged the authors to explore the prac-

ticality of creating in various areas of art expression, with the abundance of free and/or inexpensive materials. . . *Art from Scrap.*

Since the original publication, art budgets increased, federal subsidies provided for expansion of many programs, and, thus, use of scrap material was not as essential. However, we now have the initial, tight budget situation recurring. The flow of federal monies has diminished considerably. Most school districts have felt the financial squeeze, which often affects the art budgets first. In addition to the preceding, the use of found objects in art productions has become widely popular with artists and students. The ecological emphasis on recycling materials, has encouraged the use of discarded cartons, bottles, packing substances, paper and other cast-offs in art projects. Also, industry now supplies an over extending variety of

disposable materials which were not available ten years ago. Thus, the need for a completely revised and expanded edition of *Art from Scrap* has been evidenced.

Both authors are experienced public school art teachers. They have taught art education classes in colleges and universities, supervised student teachers, consulted with experienced teachers, and administered university art education programs. Their activities have brought them into hundreds of schools, and public and private school art classes. In addition to their teaching and administrative experience, both authors have continued to be exhibiting artists, are intimately familiar with the process of creativity, and are convinced of its potential in child development.

In the creative process the creator makes a statement which is completely personal and unique. This cannot be a reproduction of anyone else's work. The reader is cautioned that copying of projects may not be labeled an art activity. Hopefully, the works illustrated in this text will stimulate exploration in the creative use of materials suggested, and will motivate further experimentation with other materials and combinations. All students in a group may work with an identical material, such as egg cartons, and yet, all produce individual, creative interpretations. The only common quality or feature would be the medium itself. So, projects done with aluminum foil plates, plastic cups, or Styrofoam packing materials must all be different and personal to be valid creations! *Suggestions from this book, teachers' samples or directions must not influence or control individual expression.*

Development of perception is emphasized in child development. However, perception does not necessarily develop by participation in activities using art materials. . . as is expected so often. Planned activities need to be so arranged that they bring about a development of perceptive abilities. . . thus, students become aware of shadow patterns, textures, forms, colors, spaces, lights and darks, movement, etc. Seeking out interesting found objects and determining how they can relate to the creation of realistic, abstract or decorative forms, tends to develop perception. The student now finds excitement in areas where, previously, he may not have seen much beyond objects. This makes creating "art from scrap" especially important in an art program.

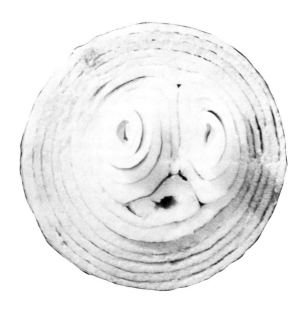

As if by magic a face appeared when this onion was sliced. A decorative mask which could be preserved only by photography. When students are encouraged to seek out and make use of found objects, their perceptive abilities are sensitized and developed.

A palm frond picked up on a Florida shore. Without any alteration, a nose, mouth, and one eye of a mask-like face appear to be present. By slight carving and/or addition of color, an attractive, man-like mask could be developed. Turn this picture upside down and it is easily seen how an elephant head, with a long trunk could be created. Or, perhaps, a curved branch could be added across the top of the head, another eye carved, and we would have a ferocious bull. Use of scrap materials, such as this, stimulates the imagination in a manner that regular art materials are not likely to do. When students begin to seek out found objects for use in art projects, we can be quite sure that they are aware of their environment and that their "perceptors" are turned on.

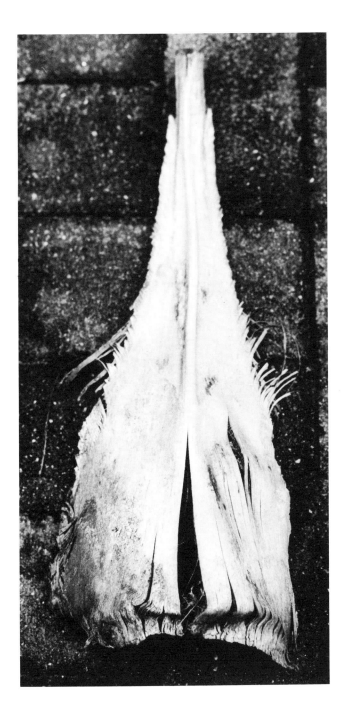

This book has been divided into three broad categories. . . sculpture, graphics, and crafts. Each category includes a wide range of materials and projects which require varying degrees of maturity, tools, and equipment. Some of the most difficult productions can be adapted to the abilities of young children. The area of crafts covers many activities and types of work, some of which are definitely in the "craft" area, and some which are less utilitarian, and are more closely allied with the "art" area. However, all are original and personal expressions.

As materials for drawing and painting are relatively inexpensive, and well serve the purpose for which they are manufactured, there seems to be little need to use scrap materials or makeshift substitutes for them. Therefore, the areas of drawing and painting, as such, are not included in this text. There is no intention of slighting these important areas of expression.

The illustrations in this book indicate only the beginning of an infinite number of worthwhile creative projects which can be accomplished with limited tools, materials, space and budget. When such a diversity of exciting art objects can be brought into being with the numerous common and readily available materials like plastic cups, hub caps, mailing tubes and foam rubber, it is difficult to justify an art program limited to crayon coloring, or pencil drawing, or to excuse denial of an opportunity to create because of a shortage of so-called "art" materials.

May the illustrations offered here motivate many happy, productive, educative hours in creativity, and hopefully provide the stimulation for further exploration with these and other materials!

Carl Reed
University of Massachusetts

Joseph Orze
Southeastern Massachusetts University

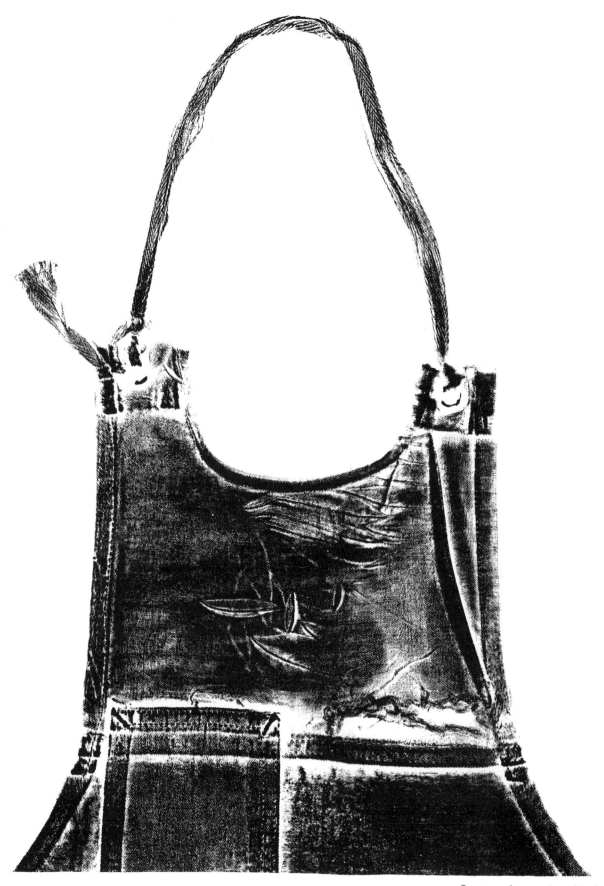

10

graphics

An inky thumb handling a paper makes a permanent impression of that thumb, as illustrated above. This is an example of the process of printing. . . graphics. Making a print requires three basic elements: 1) a shape, or character, with which to make a mark, 2) a medium (such as ink or paint) with which the mark is printed, and 3) a surface on which to print. An unlimited supply of objects. . . either scrap or still-in-use objects. . . are available for use as printing forms, and any one object may be used in repetition or combined with several other objects to make a composition. The printing medium may be regular printing ink, tempera paint, acrylics, or a stamp pad. The painting surface may be a fabric, wood, cardboard, or any paper, including printed newspaper. Try tissue papers, wrapping paper and paper towels. The only material of expense is the printing medium, and the cost of this is negligible.

The illustration at the left could have been accomplished very simply by inking the apron with a brayer and pressing it onto a paper. However, this particular print was done in a highly sophisticated manner. The apron was rolled up, or inked by a brayer, with a transfer ink. Then the apron design was transferred to a lithographic stone by a combination of hand rolling and burnishing. The stone was dampened, the lithographic ink applied, and the print was made from the stone.

Youngsters find a great fascination and a sense of power in inking a simple object, such as a sliced carrot, and making repetitions of the shape over a paper surface. Or, by using a simple shape and printing it on many sheets of paper. Older children may carefully design their characters and produce more complicated and challenging prints. Mature artists often become involved in the graphic arts through complex multi-colored block prints, engravings, etchings, lithographs, and serigraphs.

The illustrations in this section depict but a few of the many possible printing materials which can be used in *Art from Scrap* activities. One may produce prints from string, corrugated cardboard, wood, vegetables, sponges, Styrofoam, cans, rubber bands, nuts, bolts and a multitude of cast-off plastic and metal objects.

A lively impression may be made from a single object, which is repeated over the paper surface by using various combinations of colored inks or paints. Background textures can be created by painting first with burlap, screen, net, cheesecloth or any rough surfaced material. Subtle backgrounds can also be created by simply rolling the brayer, inked with delicate colors, over the background area.

Ordinary objects found in the classroom look very different when printed. This tape dispenser was painted with acrylic paint and paper was pressed onto it.

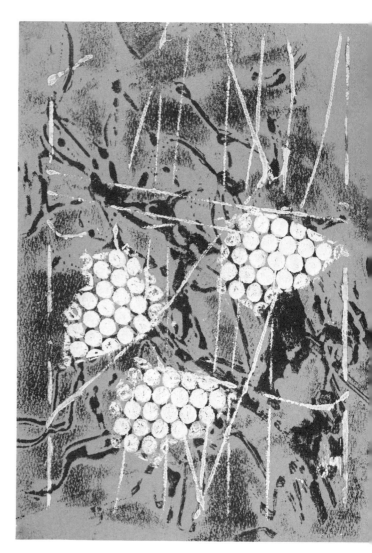

Sheets of ball-shaped plastic packing material were used to print grape-like forms. The straight lines were printed from twine wrapped around and through a tin can. The background shapes were developed with Elmer's glue dripped on a cardboard and, when dry, inked for printing.

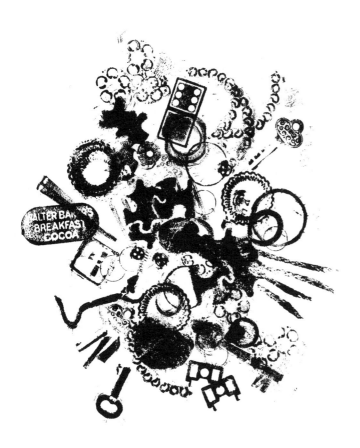

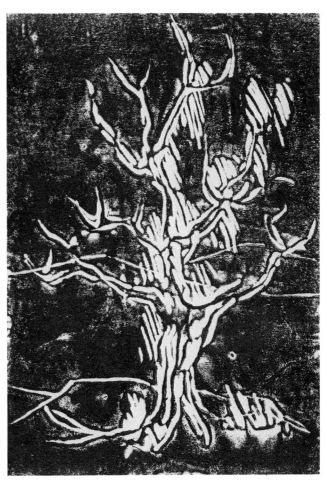

An assemblage of scrap objects which includes curtain pulls, snap fasteners, dominoes, divided electric plugs, and jigsaw puzzles, among other recognizable objects.

What! Cheese? A corrugated cardboard mouse.

The tree design was heavily drawn in copper foil. The top surface was inked, paper placed over it, and the back of the paper was spooned. If the bottom surface of the foil had been inked and printed, the white lines of the tree would appear black and the surrounding areas white. Students enjoy making such positive and negative prints.

As a variation from relief, or raised surface printing, try simple stencil printing. Cut or tear a hole in a piece of paper. Place it on another piece of paper and roll an inked brayer over the opening. The result will motivate a whole new approach to printing.

Lack of a printing press, of any sort, need not be a deterrent to an extensive involvement in graphics in the school program. In most cases of relief printing the rubbing of a spoon, a door knob, or even a hand, suffices for a press. After the printing surface is inked, place the print paper over it and then rub with objects mentioned above. By lifting one corner of the print, it can be examined to determine if more rubbing is necessary. Some professional print makers prefer this method to the use of a press.

The clean-up process is greatly reduced when water base ink or tempera is used. For the younger children these are probably desirable selections. However, the best prints can be made with an oil base ink. When an extender is used with oil base inks, very delicate, transparent colors can be created. This makes for some exciting results when overprinting of shapes is done.

A potato print, using thick acrylic paint.

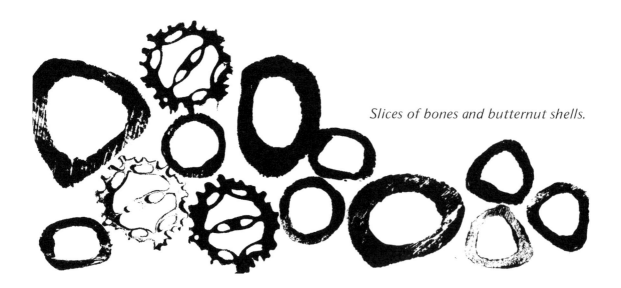

Slices of bones and butternut shells.

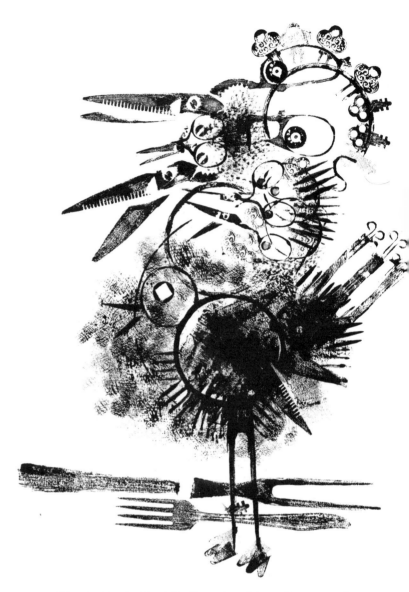

"Birds, Birds, Birds" all made with easily recognizable objects.

A screwdriver and socket wrenches were arranged in this delicate tree-like design.

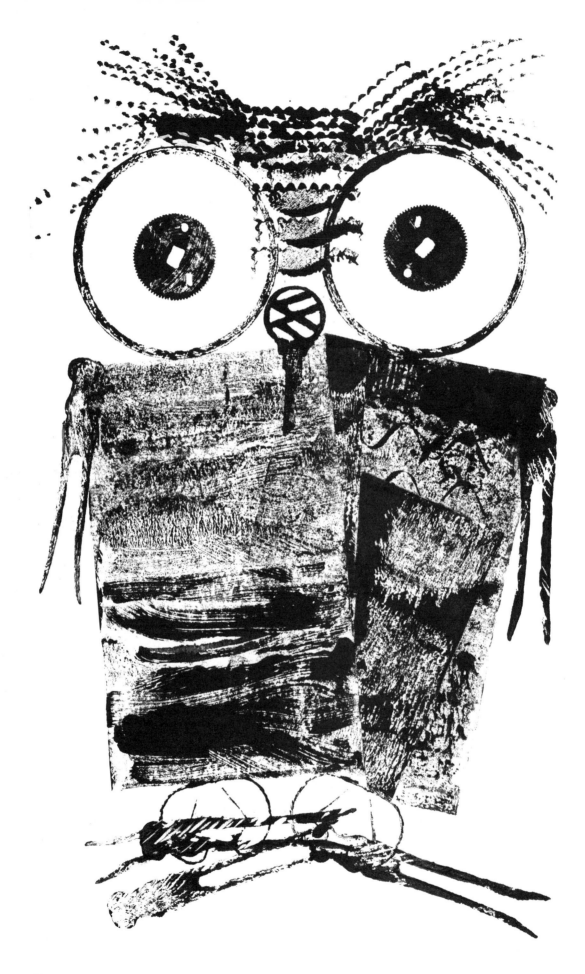

The body of this alert old owl was made with a brayer which was "inked" by painting directly on it with acrylic paint. The eyes are made with the cardboard center of a masking tape roll and a brass gear. The head was printed from a sample of artificial leather, which had been trimmed with pinking shears.

Baby's breath was placed on a paper and then rolled with an inked brayer.

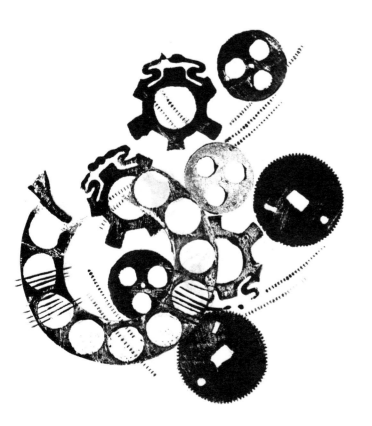

A telephone dial, and the brass gears and parts underneath it, were the only pieces used for this interesting, machine-age composition.

These cartoon faces were made with scissors, a thread spool, washer, screw eye, sponge, comb and slides from a curtain rod.

Put on a rubber overshoe, step on an inked plate and start printing. The graphic process can be simple, and yet challenging and exciting.

A pencil rubbing on an incised cardboard. A drawing of a small head was impressed into a cardboard with a hard pencil. This was then placed under the paper at numerous positions and rubbed with a very soft pencil. This same technique can be used with string, shapes of thin cardboard, coins, etc. placed under the paper. Wax crayons can be used for the rubbings. Any textured surface offers possible interesting patterns. Experiment!

Two small pieces of linoleum were used to make this pencil rubbing. On one piece the background was cut away from the design which was left raised. With the other piece the design was incised or cut away with the background left as it was. The rubbing was done with a soft pencil. Dark and light images appear, depending on whether the rubbing was done on the raised or cut away surfaces.

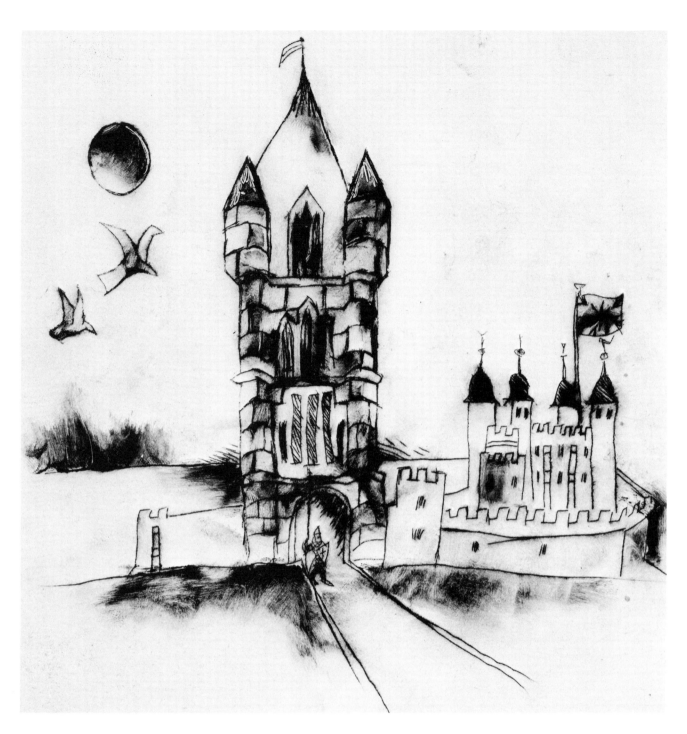

A simple form of "etching" can be done on a sheet of plastic or acetate. The lines are scratched into the plate rather than etched with acid. A sharp compass point, or an awl, serves as a scratching tool. After inking the plate, the ink on the surface is wiped off to make certain all lines are filled with ink. Then some ink was rubbed on with fingers to add darks. In places, this ink was partially scraped off in order to lighten overly dark areas. . . as in the tower roofs. Printing was done with a clothes-wringer press.

The various printing processes might be grouped into four general areas. These are:

1. Relief — printing from a raised surface such as a type face or linoleum block.
2. Stencil or Serigraphy — printing through a surface such as a silk screen, or cutout paper design.
3. Intaglio — printing from a flat surface with ink embedded into etched or engraved lines.
4. Planographic — printing from a flat surface such as a lithographic stone.

Print making is an exciting, fascinating, and challenging area of art expression, and one which invites exploration and experimentation. The various methods and combinations of expression are almost endless. Yet, for a most vital program of graphics to take place, the tools, equipment, supplies and total cost, very likely, are as inexpensive as any other area of art expression that can be imagined. Furthermore, the joy and satisfaction of participation in graphics is as great for the young child involved in the most simple levels of the activity as is the challenge, range, and gratification of the mature artist who uses complicated methods, tools, equipment, and concepts. The excitement of "pulling" the first print is similar to seeing a pot take shape on the wheel, or a photographic print develop in the dark room.

Just press an eraser onto a stamp pad and then impress it onto a paper and you are involved in the graphic process. Have fun!

Pieces of inner tube were cut and glued to a cardboard for this print. Various parts of the tube provided different textures.

A Styrofoam meat try, a plastic berry basket and cut cardboard were combined to give an impression of imprisonment.

Delicate Queen Anne's lace was coated with an oil base ink and placed on the paper before being rolled with an inked brayer. Then the ends of the lace were dipped in India ink and dabbed against the porous paper.

A print done entirely with a brayer. Water base ink was rolled out on a glass, rather unevenly, which provides much of the texture. The figure is a blob of ink which did not get rolled out completely. Parts of the print were protected by placing rectangular pieces of paper on the surface before rolling in those areas.

A moon-faced design created in three colors. A red, oil base paint was rolled out on a piece of wood. The paper was placed down on this inked base and a blunt instrument was used to press out the basic form and facial features. This process was repeated with a rolled out base of blue and black inks. The large areas of the eyes were done by thumb pressure on the back of the paper.

The objects used to print these alert and lively birds are readily distinguishable.

Rubber bands printed on a paper towel.

Corrugated cardboard was used to print the dancing figures. The straight lines were printed from a plate made by wrapping string tightly around a long strip of cardboard.

The design was drawn into an aluminum foil tray with a hard pencil (any stiff, pointed instrument will do). Then the bottom of the foil was inked and the plate was printed on a piece of old sheet, using hand pressure.

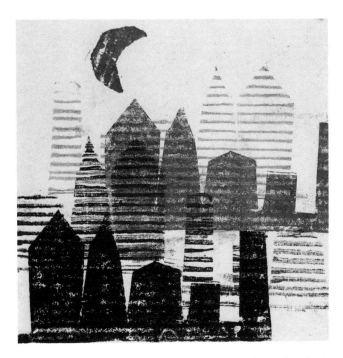

A city made with pieces of corrugated board. Black and gray inks were used in printing.

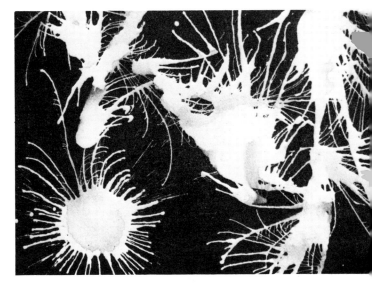

Drop heavy blobs of paint onto a paper surface and with a drinking straw blow them into desired shapes and patterns. Various colors can be used at one time causing interesting mixtures.

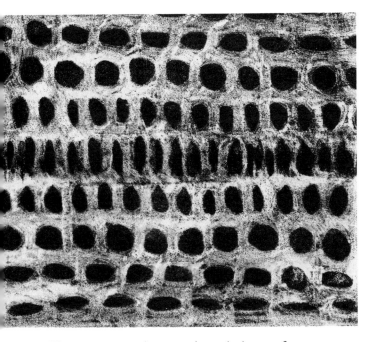

This appears to be an enlarged photo of some biological, cellular structure. It was created by drawing the design very lightly with a Magic Marker on Styrofoam. In some places the design was etched deeper by repeated strokes in that area. Experimentation with these materials will produce fascinating results for both the very young child and the mature student.

The bottom of a bottle, a piece of heavy twine and a button were the materials used to make this surprised looking face. Printing was done with an oil base ink.

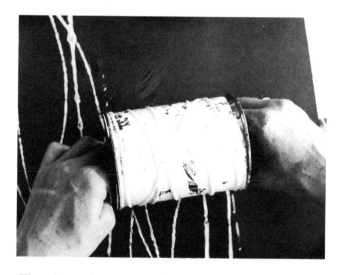

The photo shows a can being used in printing. Place the hands inside both ends of the can when rolling out the print. If the ink, or paint, on the roller runs dry, mark the inside of the can at the point where it is in contact with the paper. When re-inked the can is placed back in this position and the printing continued.

A tomato juice can, with both ends removed, was used as a base for this print. Yarn glued to the can makes the printed pattern when the can has been rolled across an inked surface and then onto a paper. Tempera paint may also be applied to the yarn with a brush. Patterns of felt or burlap may be applied to the can, or to another can for a second printing with another color. Experiment with using a stamping print, with a potato or a found object, in combination with a roller print. Tin can printing is a practical method to use when long surface prints are needed, such as for drapery material.

A chubby little "Juggling Clown" was made with a grill scraper and some socket wrenches, with a newsprint background.

A pencil was used to make the design in a rubber eraser. It was then inked and printed several times.

To do a string print, dip the string into poster paint and spread it on the paper to be printed. It is then covered with another sheet of paper and held down lightly with the hand, while the string is pulled out from between the papers. The process can be repeated with another color being added to the original print. Straight lines can be introduced to the design by snapping a taut paint-loaded string, across the design.

Twine glued to cardboard makes the plate for this eagle. After printing on a light colored paper, a pencil eraser dipped into white paint, was used to add an eye and accent dots and lines.

Elmer's glue was used to create these galloping horses. After inking the plate, hand pressure was applied to the back of the paper.

Styrofoam meat trays and a Magic Marker are a wonderful combination to use in first experiences in block printing for very young children. Lines made with the marker dissolve the foam and leave a design ready for printing without using sharp linoleum tools.

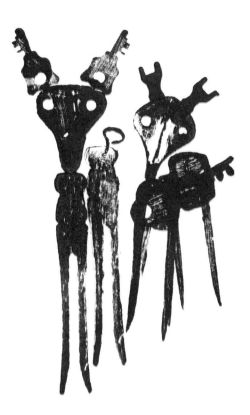

Wooden clothespins, a kitchen fork, a screw eye, keys and the plaque from a wall coat hanger combined to form these two horned creatures.

Dyfoam, a light synthetic material used for flutter boards, packing, etc. was engraved with a wooden spoon, before inking and printing. A pencil or any blunt tool can be used to engrave on this material.

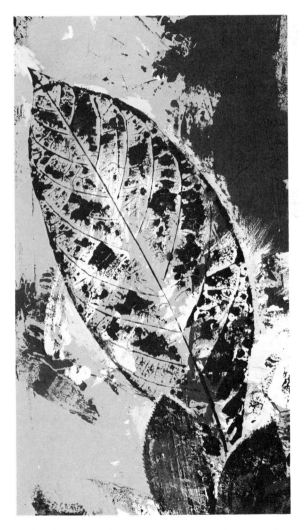

A leaf can produce an interesting shape and textural pattern when inked and printed.

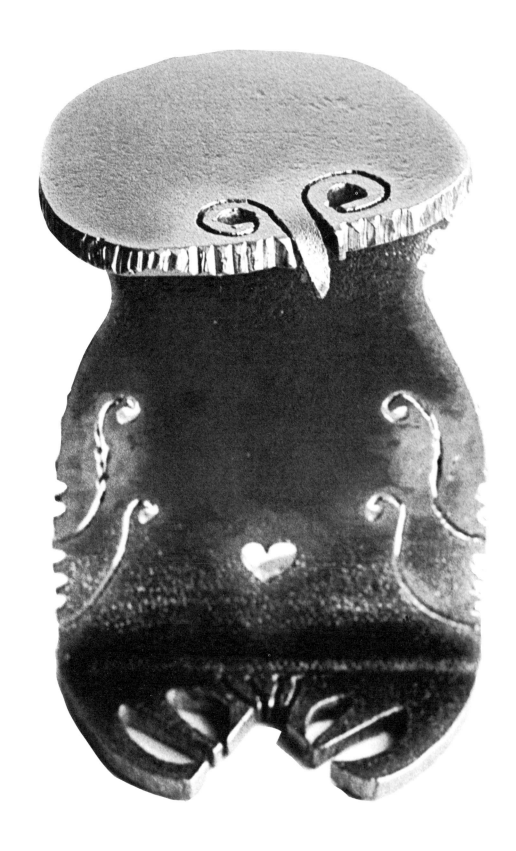

sculpture

Sculpture, the arrangement of an art form in three-dimensional design, seems to be considered an exciting art activity by most young people. This is especially true for students whose previous art experiences have been concerned primarily with two-dimensional expression, such as drawing and coloring with crayons or paint.

Sculpture moves away from the flat plane and challenges the student with involvement in creative problem solving, which includes space and form; where depth as well as height and width are factors. Sculpture also provides a satisfying tactile experience for both the creator and the viewer.

An owl cut from an I-beam by Albert Leon Wilson.

One of the earliest forms of art indulged in by man was sculpture. Cave men worked with bones, ivory, stone and wood. Although a multitude of perishable, primitive sculptures have disappeared, many remarkable statuettes of ivory have been found all over Europe. Some of these date back 50,000 years. The early Greeks produced some strikingly intricate and beautiful bronze castings, which were covered with gold leaf, and had inlays of enamel and precious stones. As far as we are able to determine, sculpture has been an important art form with every society that has ever existed. Primitive hunters and warriors carried small amulets for protection and good luck. Weapons and tools were often intricately carved, indicating a pride of ownership, in addition to serving as a means of identification.

For centuries sculpture has been thought of as a large solid object carved from stone or a bronze casting of an original wax or clay form. Currently there is a trend toward creating sculpture by assembling forms. . . many of them scrap materials.

Sculpture might be divided into three major categories: 1) subtractive, 2) additive, and 3) constructive. Carving away stone or wood is an example of the subtractive method. Building up forms with modelling clay, or wax are processes used in the additive method. Wax is usually cast in bronze to make a permanent piece. In the constructive method, any number of materials may be used singly, or in combinations, and are joined by welding, soldering, stapling, gluing, etc.

The subtractive method need not employ such intractable materials as stone or hard woods. Rigid and durable sculptures may be done from easily carved materials such as plastic foam, balsa wood, foam rubber, or from the many mixtures of plaster of Paris which are described at the end of this book.

In the additive process students may use, in addition to cheap and easily obtained waxes and clays, homemade materials such as papier-mâché. For large structures a framework of wood and screening can be made and covered with a coating of wax or papier-mâché. Many plastic metals are available, from auto supply stores, which can be applied in a thin outer layer, resulting in a very durable struc-

ture. This metal, after becoming slightly hardened, can be filed and sanded, like wood, to a very smooth finish and then spray painted.

While many adult artists use heavy metal and welding torches in the constructive process, more easily handled materials can provide challenging creative problems for the young artist. Interesting art forms can be developed from such light and delicate materials as toothpicks, wire, drinking straws or eggshells. Many suggestions are presented in this section on sculpture. There are several brands of metal adhesives, available under various trade names, which enable students to join rather large metal objects without the necessity of welding.

Perhaps, one of the most important advantages of using found objects as a basis for sculpture is that it offers a solid form on which to build. This helps the reticent student over the hurdle of trying to start with a vacuum. Often a found object will suggest an abstract, human, or animal form, which can then be developed by adding other scrap materials. It is this type of activity which tends to develop perception.

As sculpture is such an interesting and challenging art activity, and since there is a plethora of material available at little or no cost, there seems to be no economic or pedagogic reason to deny students the opportunities to participate in sculpture. Both students and teachers will be rewarded!

wood

Scrap wood is probably one of the most readily found materials that can be easily arranged into simple but effective sculptures by the very young child, and also can be used in creating sophisticated sculptures by older students and mature artists. Wood scraps can be collected from building sites, cellars, garages, attics, home and school shops, city dumps and in the streets.

The towers of a medieval town are brought to mind by this scrap wood assemblage by sixth-grader Robin Spear. Note the interesting play of horizontal and vertical movements. Scrap wood came from a local manufacturing company and the finished piece was spray painted. Bette Benien, art teacher, Bryan City, Ohio.

Michele Seek, a seven-year-old, assembled the "Ferry Dock" from wood scraps found in the industrial arts shop. Judy Webley, art teacher, Lynwood, Wash.

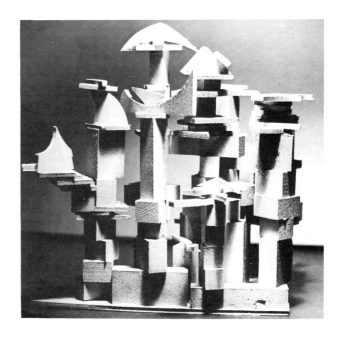

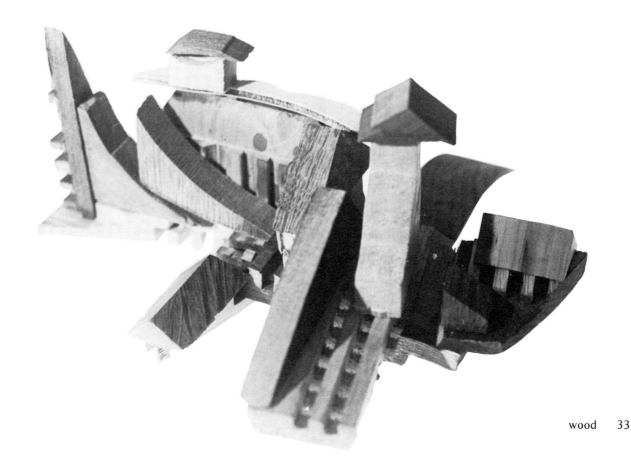

The joy of creativity and its all consuming attention are evident in this young Newton (Mass.) school girl working on a scrap material construction of an animal. Al Hurwitz, Art Supervisor.

Scrap wood, Tinker Toys, bobbins, spools, boxes, reels and other materials were used by 9-, 10-, and 11-year-old students of Liz Smith, Central, S.C.

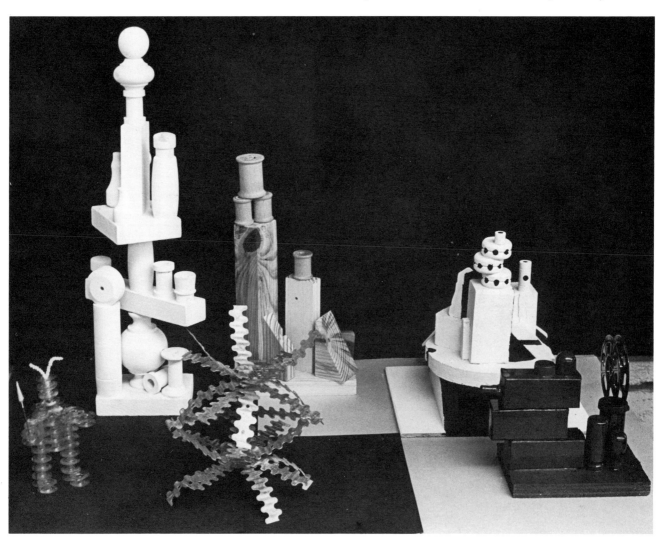

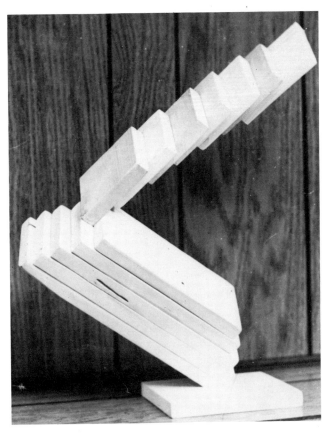

A dynamic, laminated wood sculpture by Lori Sloper, a seventh-grade student in Milltown, Wisc. Dan Kerkhoff, art teacher.

Thin bamboo strips and toothpicks were used by Wendy Wiebusch, an eighth-grade student. First the bamboo was shaped and glued with a fast drying glue such as Duco cement or model making cement. Then the toothpicks were arranged and glued into place and the finished sculpture was spray painted. Gayle Sundt, art teacher. White Bear Lake, Minn.

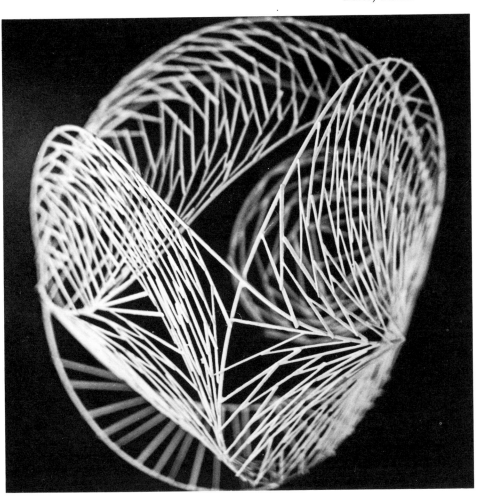

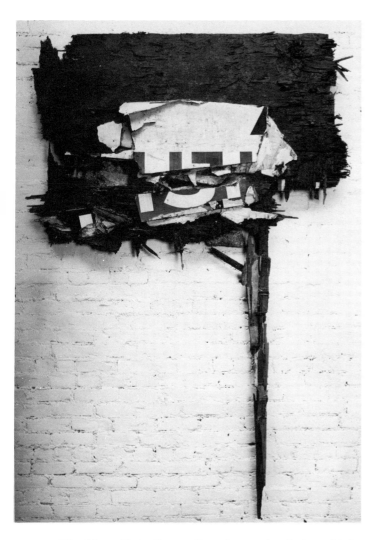

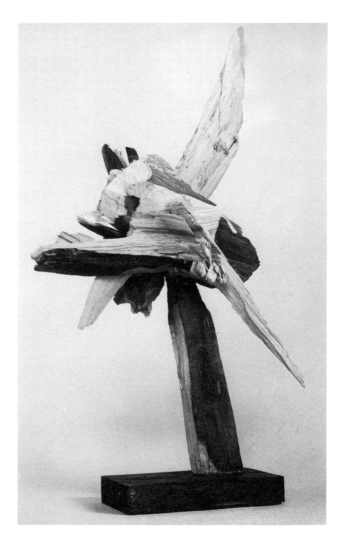

"Le Marseillaise", a wall sculpture by Robert Mallory. Deteriorated plywood, wood scraps and billboard tearings are brought together into a composition made durable by a coating of synthetic plastic and backed with welded steel rods. The Maremont Collection. Photo courtesy of the artist.

David Hysell, a mature artist, assembled this "Bird" from the leftover, rough choppings and sawings of an elm log that was being sculptured.

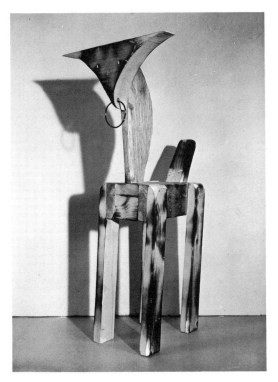

The saucy animal was constructed entirely from wood scraps found in an industrial arts shop. No pieces were reshaped. A burning candle was used to add color and a metal ring was placed in the "nose".

Nature provides many materials for creating animal, bird, man, and abstract forms. The little mouse is made from twigs and seed pods. Bits of colored cellophane were added for eyes and ears.

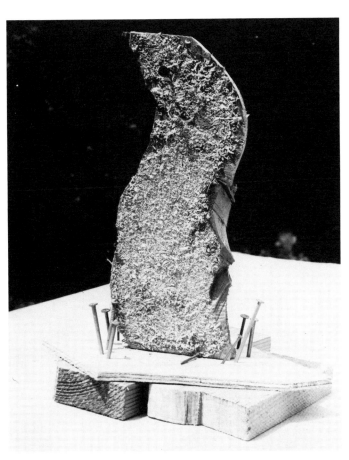

"Bird in a Nest" by Katie, age 8. Scrap wood, sawdust and nails were used in this delightful version. Courtesy Margo Kren, Kansas State University.

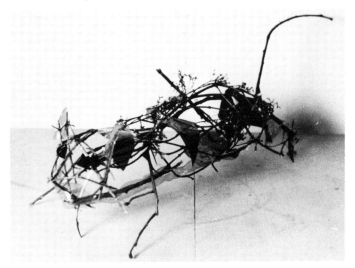

metal

Scrap metal pieces of many sizes, shapes, and states of newness or corrosion are waiting in abundance to be collected and used for sculpture. Garages, farms, junk yards and dumps are prime sources of scrap metal. Because of the durability of metal some very old pieces can be found. Many artists make use of the interesting color and texture caused by corrosion. When very smooth surfaces are desired, plastic metal may be applied and filed and sanded. This material may be spray painted to provide exciting, gaily colored productions.

Older students may use acetylene torches for cutting and welding. However, for younger children there are many commercially available metal adhesives for joining metal parts. Aluminum cans can be cut with ordinary scissors.

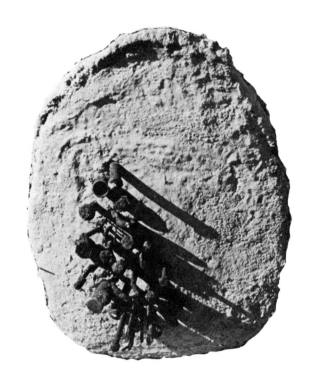

Pieces of bolts, rods, tubes and nails, found around a farm, were embedded in a puddle of wet cement cast in hollowed out turf.

When the form hardened black cement was plastered over the back. Then some of the black cement was trowelled over the edges covering some of the front and a flat base was modelled. Wads of newspaper held up some sections of the black cement, protecting the light surface, while it set. This gives the effect of some of the dark cement having been folded back from the face of the sculpture.

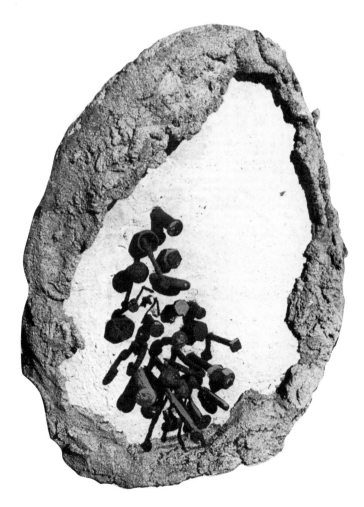

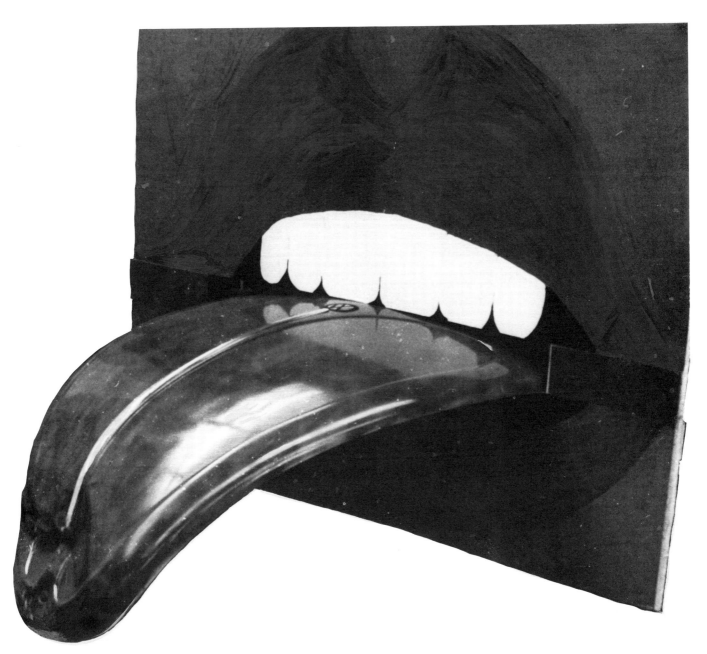

A Volkswagen hood sparked this large sculpture by
Edward Winnick of Lawrence High School. The
lips and teeth are painted on a plywood form.
Auto parts provide many stimulating shapes for use
in metal sculpture. Sylvia Schwartz, art teacher.

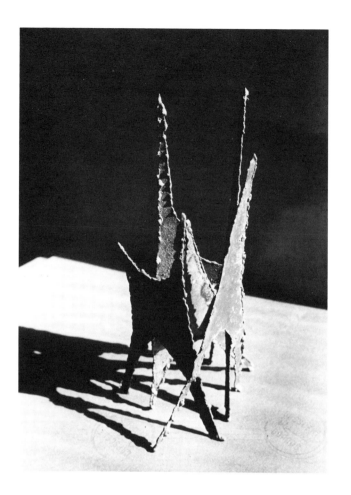

Pieces of an oil drum cut and joined with a welding torch.

A single section of an old I-beam provided the raw material for sculpturing three men by Albert Leon Wilson. An oxy-acetylene torch with a flame of six thousand degrees cuts away any unwanted steel. Wilson does not add any material to the beam and only occasionally bends a shape in creating an unlimited number of original sculptures. Wilson Gallery, Rochester, N.Y.

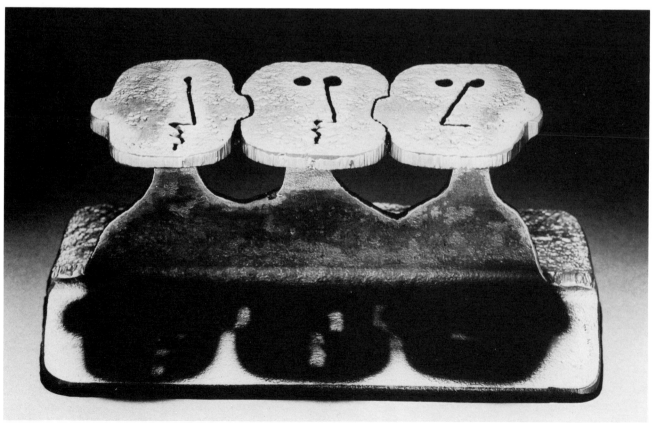

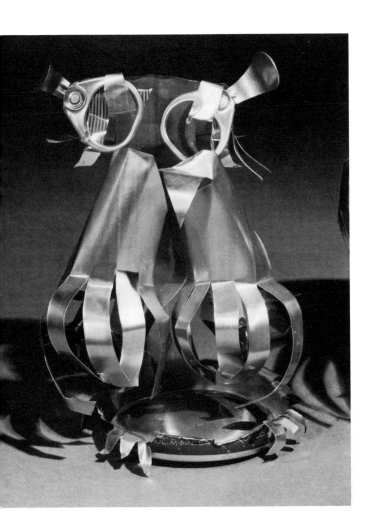

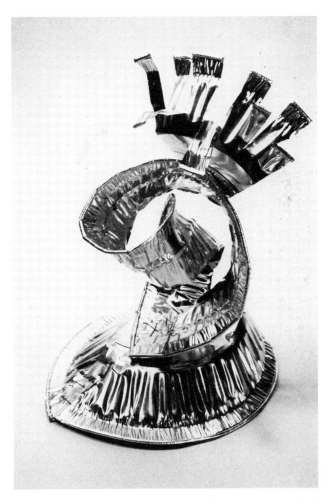

"An Owl" made from a single aluminum can. The pull-outs from two cans were used for the eyes and ears. Cans were cut with ordinary household scissors and bent by hand. The owl vibrates from the slightest puff of air. Harry Wood.

Aluminum pie plates were cut, shaped, and stapled together.

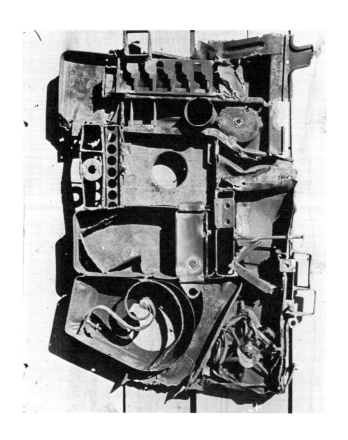

The New Haven city dump provided all the raw material for a welded wall sculpture by Arthur Gaugliumi. The metal is mounted on a rough wood crate.

Scrap steel and iron left in the welding shop at the end of the year were assembled by eighteen-year-old Don Edwards. Photo courtesy Margaret Steinhauser, Trott Vocational H.S., Niagara Falls, N.Y.

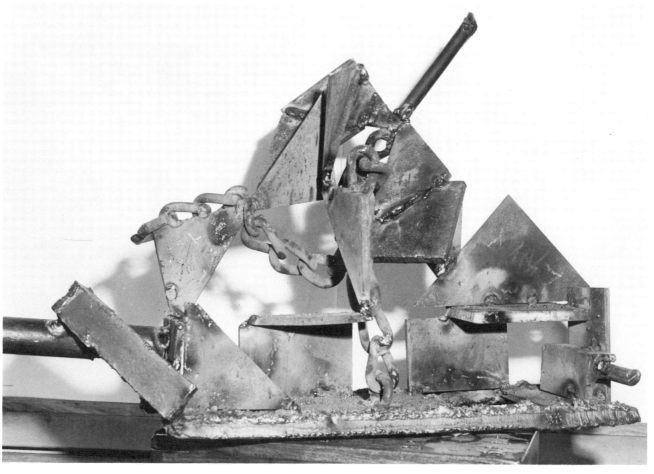

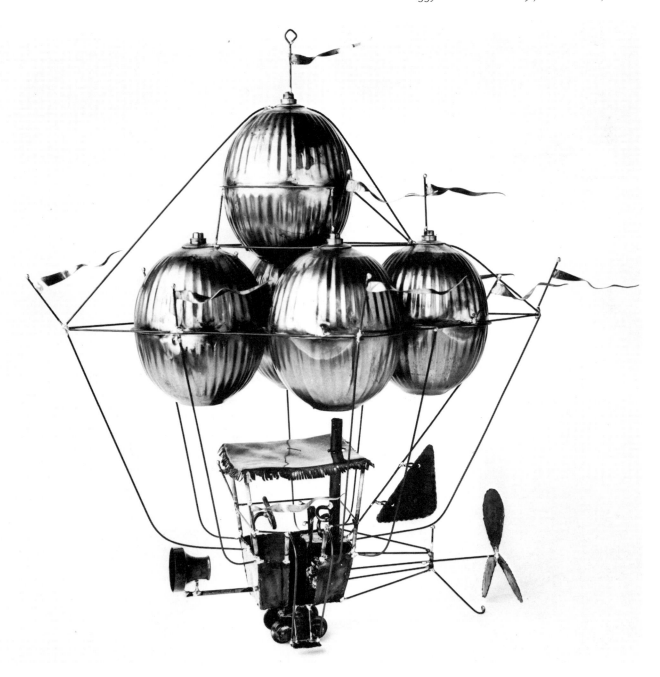

"Cross Town Trolley." Pieces of scrap metal, rods, and water tank floats were used by Brian Wilson to create this buggy. Wilson Gallery, Rochester, N.Y.

"The King" by Harry Wood. The hair piece is squeezed down on the face section and held securely by friction.

Metal, wood, wire, boxes and tubes were joined by glue, solder and wire to create this interesting construction. Rochester City Schools.

An assemblage of cans, covers, spools and other found objects mounted on Styrofoam and cardboard by Esperanza Mendez, an eleven-year-old student in the Texas School for the Deaf. The art teacher, Kit Neuman emphasizes that deaf children are not handicapped creatively in the plastic and visual arts. They appear to enjoy becoming engaged in the same art projects as all children do.

"The Castle" made entirely from the interior of a muffler. An acetylene torch was used for cutting and welding. Carl A. Reed.

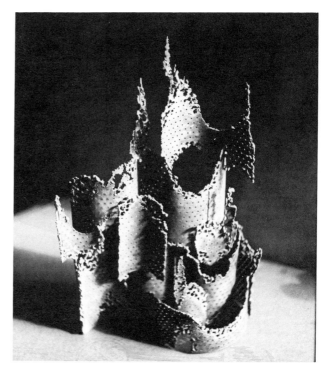

paper

Paper lends itself to many constructions. Newspaper (printed and unprinted), towels, billboard sheets, poster board, and scraps left at the paper cutter can all be used in art projects. Newsprint paper can be made into papier-mâché for modelling or can be used in strips to join parts or to cover armatures. Sheets of stiff paper may be folded and bent to create paper sculptures. Experiments with three-dimensional structures made from flat sheets of paper can provide hours of challenging creative exploration.

Sheets of papier-mâché were made by building up six layers of newspaper and wallpaper paste. When these sheets became leathery hard they were cut and shaped. When dry, the head and body were joined with strips of paper and paste. This technique makes possible a variety of rigid — free form sculptures without the use of any armature.

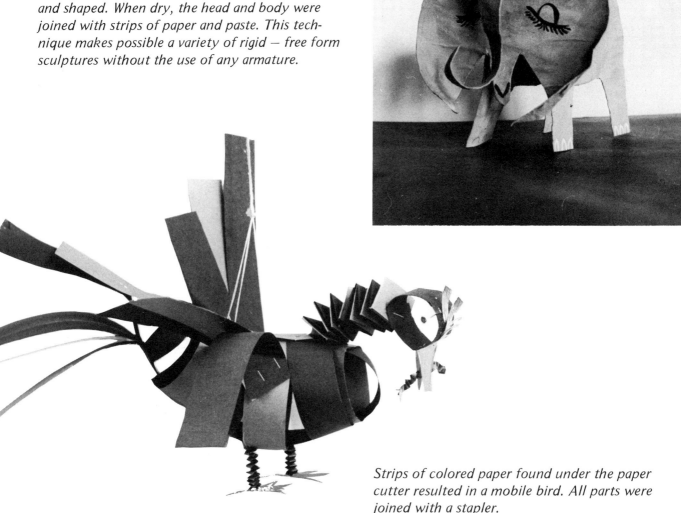

Strips of colored paper found under the paper cutter resulted in a mobile bird. All parts were joined with a stapler.

Newsprint cut into long strips and arranged on edge in a shallow wooden box resulted in an interesting textured wall sculpture. Andover (Mass.) Academy.

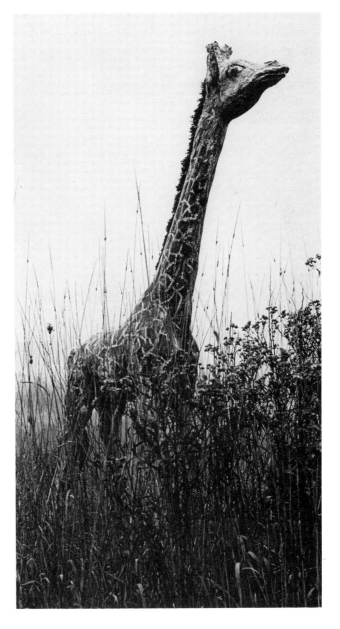

An eight-foot-tall papier-mâché giraffe was constructed over an armature of wood and wire screening. A cellulose wallpaper paste was used. Old bed sheets were used for the final layer to provide a durable "skin" texture. Artist, Ann Friend.

The basic materials used are evident in this photo. Though the armature materials are rigid, great flexibility is achievable in the manner of combinations. Cutting, bending and adding make almost any form feasible.

Mailing tubes and boxes were covered with papier-mâché and Pariscraft to create this pert, spotted, striped animal. East High School, Rochester, N.Y.

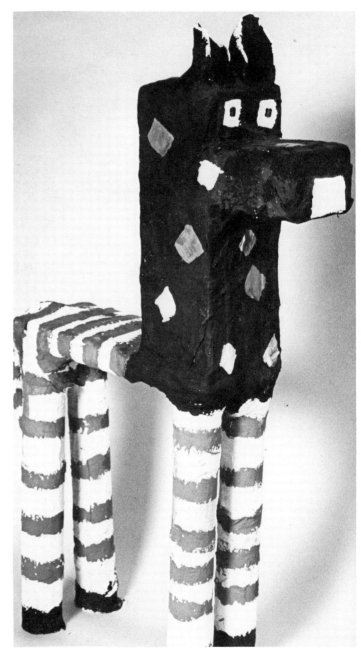

Denny Marvel, a fourth-grader in Bryan City (Ohio) developed this ferocious lion with papier-mâché over a wire armature. Wheat paste and newspaper strips were used. Yarn, felt, thumbtacks and paint were added. Bette Benien, art teacher.

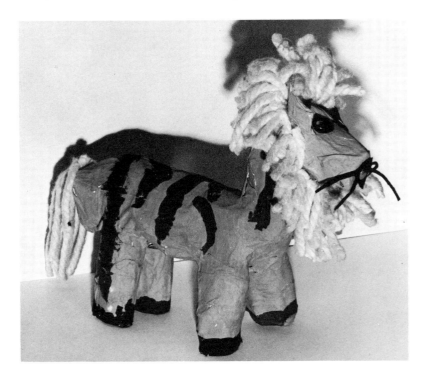

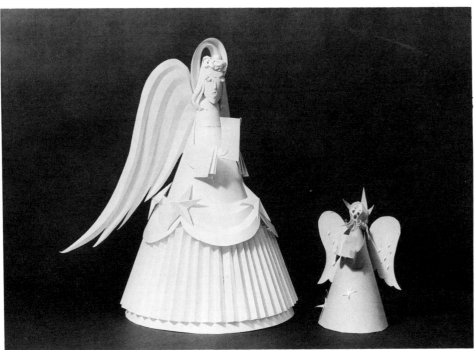

An adolescent and a first-grader each interpret an angel with a sheet of white paper.

packing materials

Packing materials in a large variety of synthetic and natural substances, which are usually discarded at unpacking time, can be used to create exciting art forms.

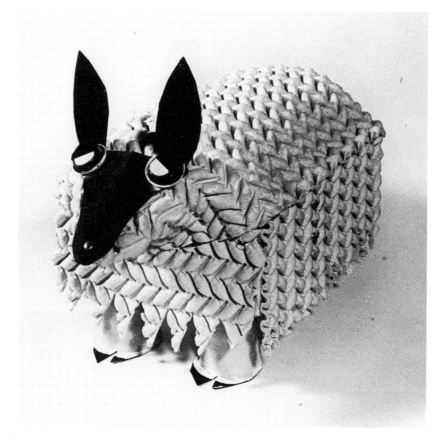

Another form of rubber packing material supplied the covering for this woolly sheep. Brass paper fasteners joined the "wool" to the box body. Thread cones form the legs. Towne photo.

Foam rubber was used to create an interesting plaster sculpture. A torch cut, or melted, a rectilinear hollow in the foam rubber. The brownish residue, caused by the burn-out, adhered to the plaster in casting. Evie Vigness, Three River Falls, Minn. Don Lerud, art teacher.

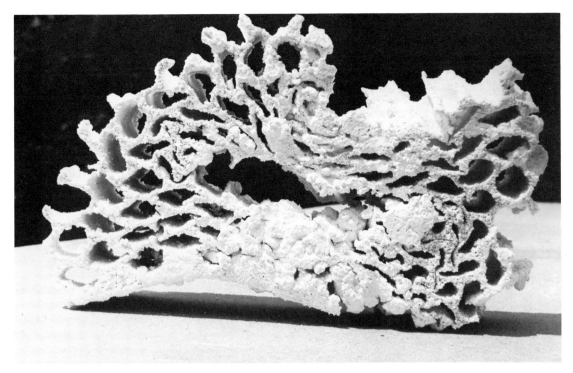

It may look like coral from the bottom of the sea, but it is really foam rubber from the bottom of a shipping crate. Soaked in plaster and teased into the form you see, by Carla, a ten-year-old student of Margo Kren.

Styrofoam may be easily cut or sliced with a "hot wire" cutter. Rochester City Schools.

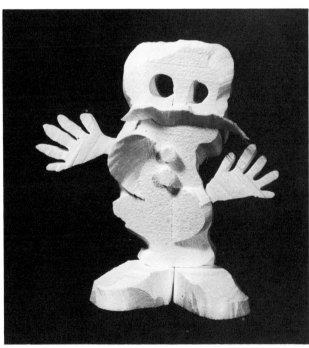

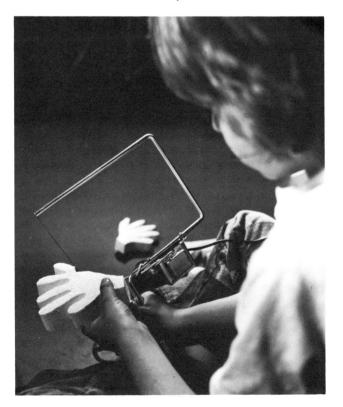

Styrofoam, which is easily shaped by youngsters, was used to form all the units of this lively figure. Parts may be glued together or fastened with toothpicks.

plaster

Plaster is relatively inexpensive material which can be combined with diverse scrap materials in developing sculptures. It can be dripped over structures of wire, string, cardboard or wood to provide an interesting and consistent overall covering. Plaster can be mixed with different materials to make practical blocks of varying degrees of solidity for carving. (See section on Formulas and Mixtures at the back of the book.) When cast plaster is soaked in water it becomes considerably softened for carving. This is helpful when sculpture is done by young children.

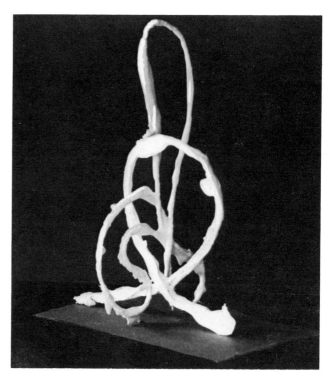

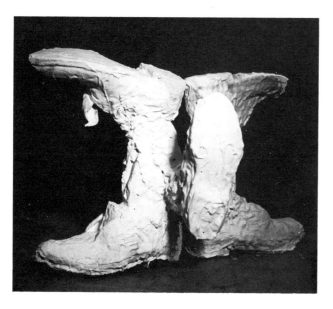

Three pairs of army combat boots were joined and dipped in plaster to create this unusual sculpture.

String and plaster. Dip string, or heavy twine in wet plaster and then lay it out in desired shape onto wax paper to harden. When various shapes have been made in this manner they may be arranged and joined by wet plaster or some adhesive.

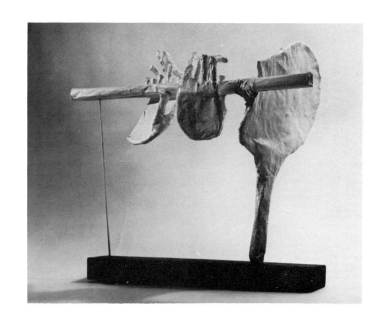

"The Flute Player" by Jill Sprayregan of Fort Lee (N.J.) High School. A wire armature was covered with cloth dipped in plaster and sprayed with white enamel.

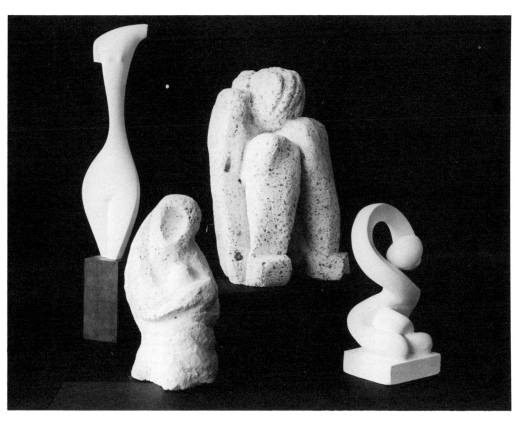

Four figures in plaster and plaster mixtures. The foreground "Madonna" was made with a mixture of plaster and baking soda by a ninth-grade girl. The stylized figure behind was made with pure plaster over a supporting wire armature. The other background figure was carved from a block made from plaster and Zonolite by a college freshman. The remaining white sculpture was created by a high school girl who worked from a cast block of white plaster. (See formulas and mixtures at the back of the book.)

containers

Containers for use in sculpture are available in an almost endless supply. The materials include plastic, foam rubber, paper, corrugated cardboard, Styrofoam, aluminum, tin, wood, etc. Most of the materials are easily worked and the enormous variety of forms is stimulating to creative thinking, suggesting all sorts of real and imaginary forms.

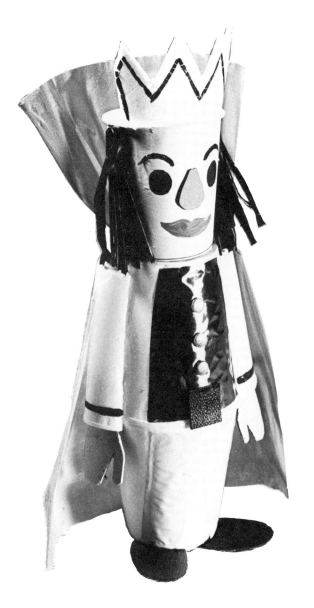

Various disposable coffee cups provide all the basic structural materials for this "king". Rochester City Schools.

Egg cartons were joined together with papier-mâché and coated with gesso. Various parts of the sides and bottoms of the cups were painted with values of gray or black acrylics before mounting on a sheet of peg board painted black. As the viewer moves about the wall sculpture, the shapes and value patterns appear to be constantly changing.

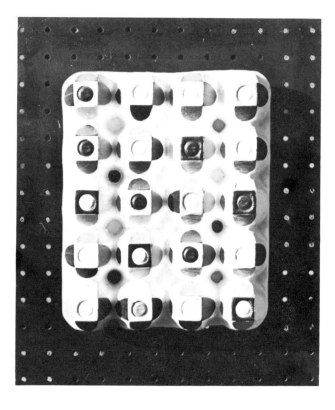

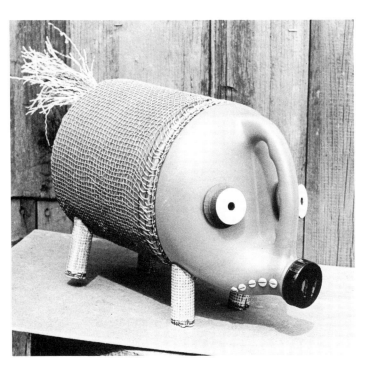

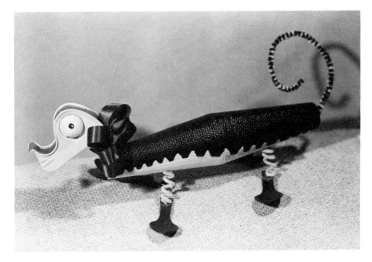

A tan colored, plastic detergent jug suggested an animal that was developed into an amusing, inquisitive looking pig. The body is covered with a potato sack made from colorful artificial fibre. The tail is formed from the end of the sack. The eyes are made from a wooden thread spool sawed in half. Cardboard yarn spools provided the legs, and self-threading screws suggest a mouth.

"Scotchie" with a body made from two yarn cones. Other parts are self-evident. Bloomington (Ill.) High School. Elizabeth Stein, art teacher.

A turtle made from papier-mâché egg cartons. This material can be softened with water and modelled to a desired form. Staples were used to hold various parts together. Phil Caruba.

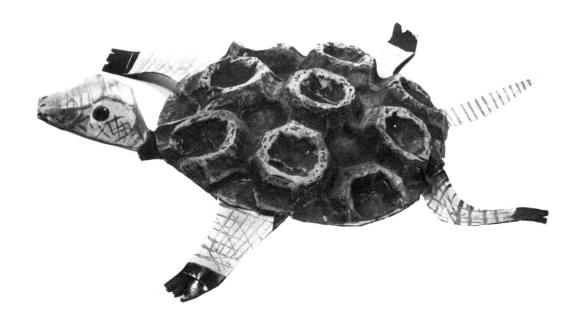

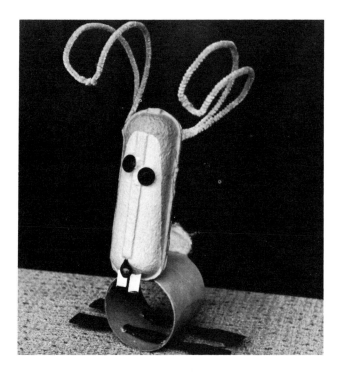

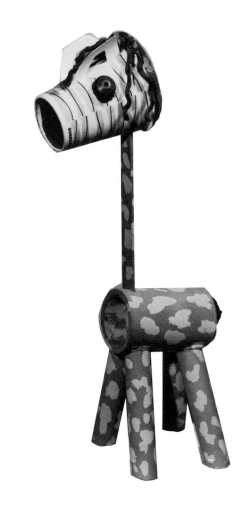

A sausage carton suggested a head, and the "animal" developed from there. Imaginative animals like this can be easily motivated when there is an ample supply of found objects available in the classroom. Collecting and sorting them will pay off. Elizabeth Stein, art teacher. Courtesy Arts and Activities.

A turtle was formed with a cardboard meat carton for a shell, which was covered with the net from a lobster trap. The head is a sea-battered golf ball found on the beach. The tail and eyes are made from the rubber straps of beach sandals.

A giraffe assembled from yarn, a paper cup, buttons, a yardstick and paper tubes. Courtesy Elizabeth Stein.

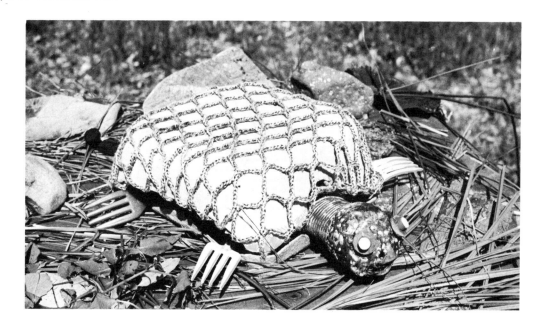

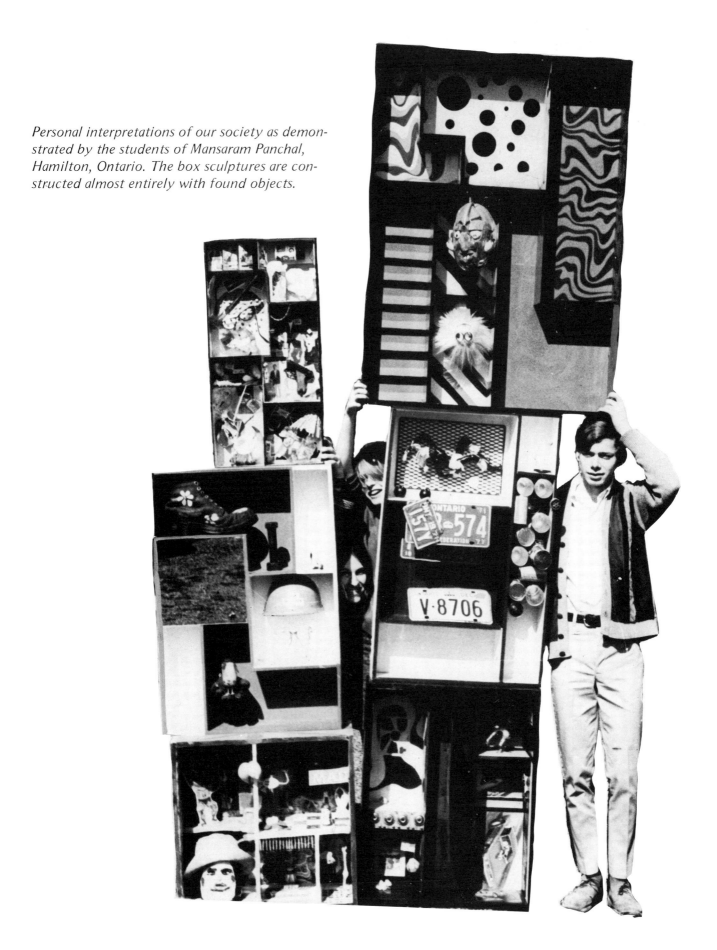

Personal interpretations of our society as demonstrated by the students of Mansaram Panchal, Hamilton, Ontario. The box sculptures are constructed almost entirely with found objects.

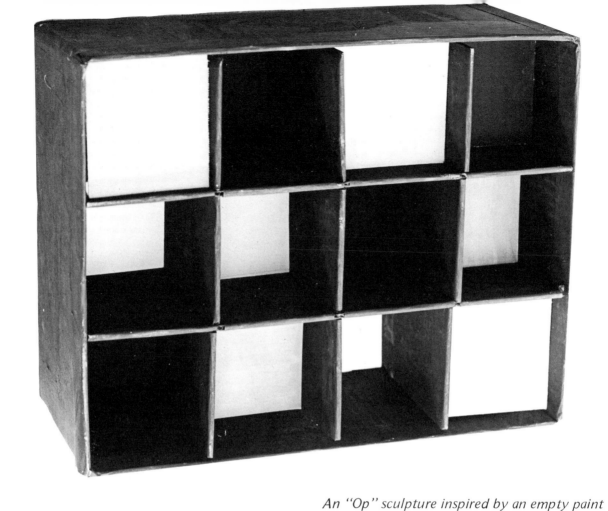

An "Op" sculpture inspired by an empty paint carton. Various colored cardboards were cut and set into the compartments at different depths, after the entire box was painted black. The size and shape of the colored squares change as one moves about the sculpture. Nyack (N.Y.) Public Schools.

A cardboard box covered with paper was turned into a ferocious alligator with a skin texture of Duco cement.

Printed billboard paper gives dramatic color to an unusual bird by Phil Caruba. Other parts include a cardboard can, dowel sticks and a cardboard box.

An attractively sculptured form constructed with soda straws and a mailing tube painted to match the straw colors. Joan Di Tieri, art teacher, Fort Lee (N.J.) High School.

Empty boxes provide all the raw materials needed for this upright sculpture.

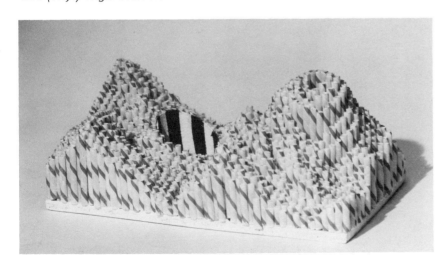

wire

Wire may be extremely pliable and easily shaped or it may be rigid and capable of supporting added weights. Coat hanger wire is of the stiff, not easily bent variety, whereas there are many soft iron and copper wires. Heavy gauge copper wire can be readily bent and hammered, with little effort, into a variety of forms. An abundance of copper wiring can be found with coverings of many colors.

"A Bonsai Tree" made with colored telephone wire, an electronic circuitry board, and a wooden base — all found at the Amherst town dump. The bottom of the tree is recessed into the wooden base. Richard Martin. Art teacher, Blanche Derby.

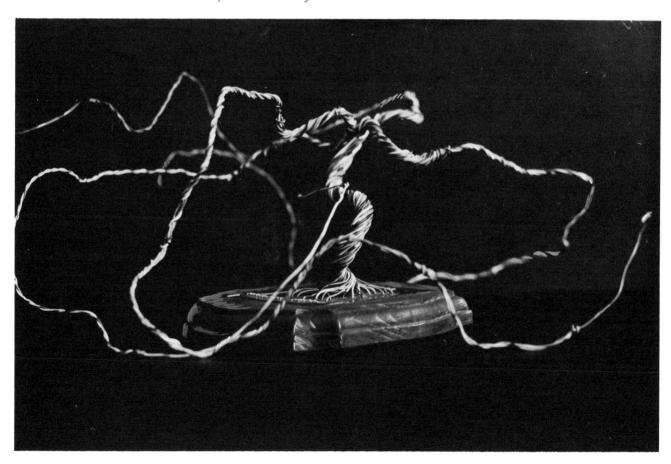

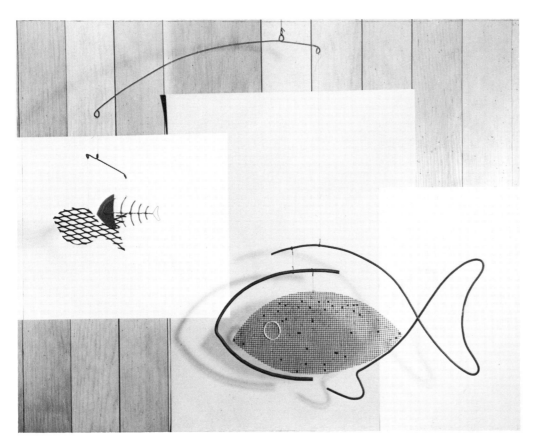

Wire is the basis for this mobile. The support arms are steel clothes hanger wire. The two small fish are expanded metal lath and wires from milk bottle tops. Aluminum wire of two different gauges forms the large fish with a body of wire screen. Some holes in the mesh are filled with Duco cement, which sparkles as the fish revolves on its nylon thread.

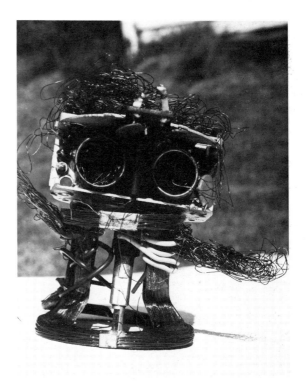

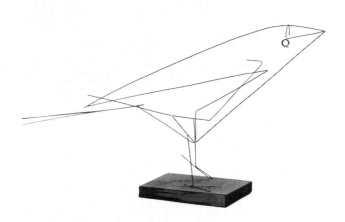

Light gauge steel wire was soldered to create an interesting bird of straight lines. Courtesy Pratt Institute.

Wire and old television parts were turned into a robot with great success, by Katie, a third-grader. Margo Kren, art teacher.

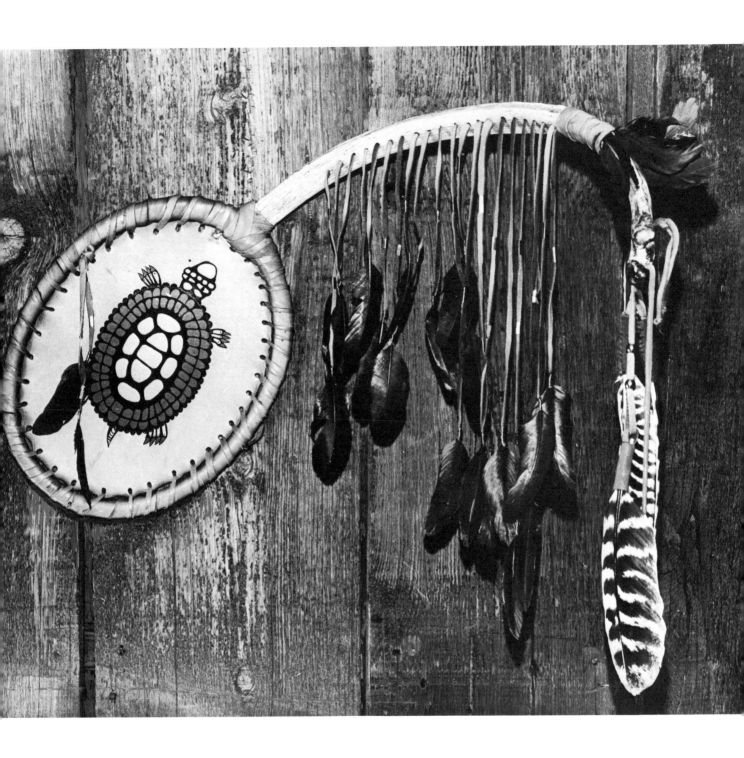

crafts

It is hard to say when man created the first work of craft. Perhaps it was when he crudely chipped a stone to make it a more effective handweapon. Then, it might have been when he first painted himself or wore the teeth, claws or feathers of his kill. We cannot be certain just what man's first handicrafts were. We assume that whatever they were they were a result of his will and efforts to survive; but, even of this we cannot be certain, because art history is filled with early artifacts of man which seem more decorative than utilitarian.

"Buckskin and Feathers" by Peter Jacobs. A handsome wall decoration made from natural materials including buckskin, rawhide, turkey and crow feathers, and an elk's rib. The large oval form is the wooden frame of a tennis racquet head.

The two skeins of utility and decoration are interwoven throughout the development of man's crafts. If we study the early artifacts of primitive man we see this dualism clearly. The paleolithic cave dwellers created some quite skillfully designed hand tools and decorated many of them with magical symbols to make them more effective as well as more aesthetically pleasing. A more recent example of this combination of the utilitarian and decorative would be the pottery of the American Indians. From crudely formed water carriers and storage pots they evolved into very beautifully shaped and handsomely decorated forms. The water carrying and storage capabilities changed very little from the earlier crude forms, but the aesthetic appeal was greatly increased. We can only assume that an inner aesthetic sense, a striving for the beautiful, had an important part to play in the development of this art/craft form.

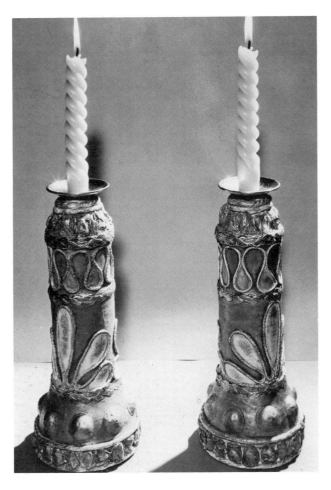

As we become involved with crafts problems working with scrap materials, the dualism of utilities and decoration needs to be considered. Crafts, no matter who the craftsman or what the material, may be broadly defined as creative activity with a specific purpose or use in mind. Then, if they are creative and original, they are technically works of art as well as functional objects.

Crafts today are experiencing an upsurge of interest at all levels. There is increasing professional crafts activity and children and adults are finding a great deal of excitement and pleasure working with wide varieties of materials and processes in the crafts.

The old battle of the artist versus the craftsman is being fought less and less today. Recent trends have focused upon raising the crafts toward a more creative level and away from an approach in which technically capable mechanics have copied works and styles of true artist/craftsmen and therefore considered themselves as "craftsmen."

The works in the following crafts areas are the result of people, young and old, approaching scrap materials in a creative manner and working through and solving crafts problems in original ways. The ideas offered in these areas are not to be copied if the reader expects to work as an artist/craftsman. It is hoped that what is presented will become stimuli for further creative activity.

Candlesticks made from various scrap containers covered with papier-mâché, sprayed with gold paint and then rubbed down with paint to give an antique effect. The materials used, reading from the top down, were: a tennis can cover, a plastic towel holder, an inverted lid, a tin tomato paste can, a soup can, and an inverted plastic margarine container embellished with cups from an egg carton. The base is a three-quarter-inch-thick disc of foam rubber. Cairo (N.Y.) High School. Martha Mattice, art teacher.

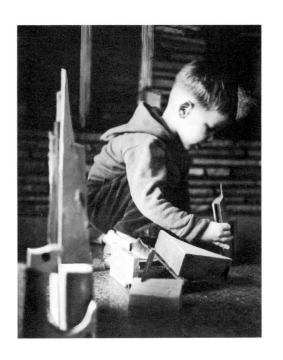

When the pre-school child combines various scrap materials, he readily imagines garages, castles, sculptures, and people. Creating is an activity which can be enjoyed by people of all ages.

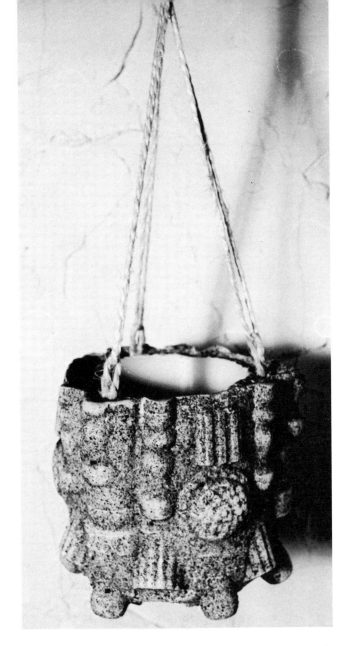

Plant pot encased in a sand casting. Design created by pressing wooden furniture scraps into sand mold. William Barry.

The beauty of natural and man made forms were combined to produce this delicate piece by Richard Martin, a student at Amherst (Mass.) H.S. The base is Plexiglass fashioned to contrast with the moonshell. A paper clip and small dried flowers (held in place by putty in the shell) give exciting linear elements to the composition.

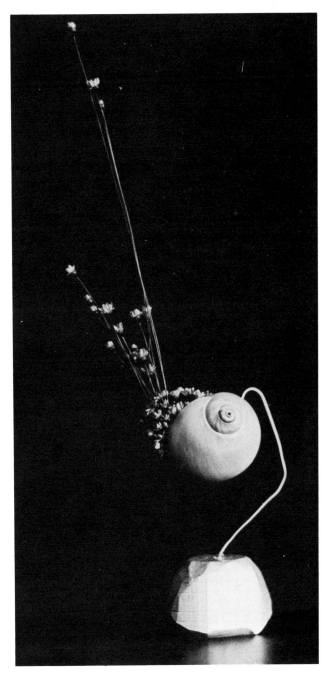

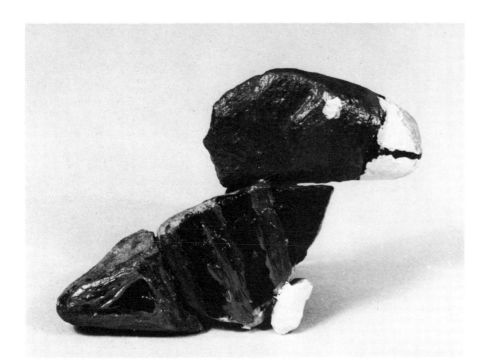

Rocks, glue and paint can create a community of individualized people or a menagerie of unusual animals. Art teacher Ann Bruno of Sierra Vista (Ariz.) introduced this project to fifth-grade students. Animal by Eddie Messmer.

Styrofoam scraps, wire and white glue were used by an eighth-grade girl to create this bouquet. Art Teacher: Vija Hamilton, Von Tobel Junior H.S., Las Vegas, Nevada.

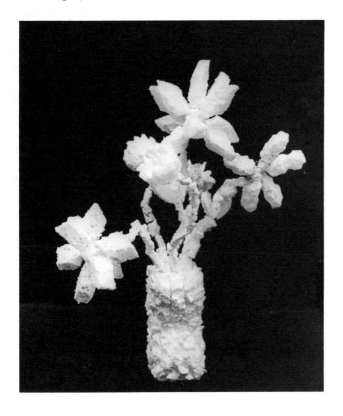

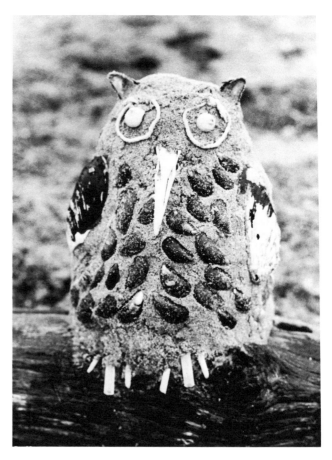

Wet sand was used to shape the body of this owl. Then shells and twine were added for feathers, eyes, ears and wings. A seagull provided a beak and quills for feet.

The Hopi Indians of the Southwest believe that their ancestors live as gods in the high mountains, and annually, masked dancers, in the images of these gods, dance in their honor. These gods are called Kachinas and many images of them are made in the form of dolls. These dolls are made from the roots of the cottonwood tree which is very soft. In northern areas, poplar or aspen may be used. Balsa wood or pine make suitable substitutes. The dolls provide the base for much freedom and experimentation in design and color.

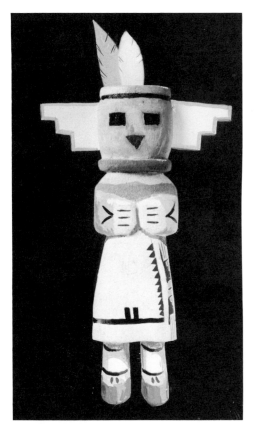

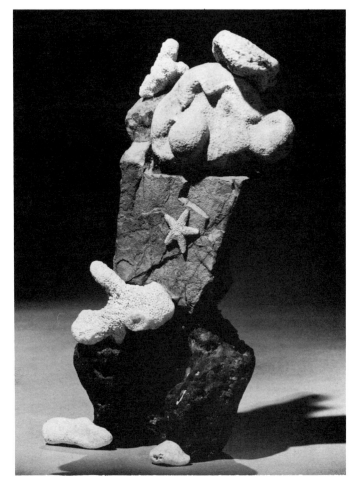

"A Law Officer" made from Hawaiian coral, lava and starfish, with a jacket of red sandstone found near Sedona (Ariz.). Epoxy holds the pieces together. Artist, Dr. Harry Wood.

Materials are only a part of a crafts problem. They may present various possibilities and limitations to the person working with them due to their inherent qualities. It is up to the individual to imbue the product of these materials with his or her personal identity. Materials may be limited by common qualities. Individuals are unique and this uniqueness can always be put forth through creative activity no matter what materials and processes are used.

The teacher who encourages students to work with any of the ideas in this book should always encourage them to approach each problem individually. Their own personal interpretations rather than "how well" they copy someone else's are the important considerations.

Illustrated material included in the book as crafts projects developed from scrap materials is but a small fraction of the possibilities that exist in this area. Crafts can include a multitude of materials and processes. Part of their excitement is their almost limitless possibilities for creative activity. Remember the dualism of utility combined with the decorative and have fun with all the possibilities open to you for crafts experiences using scrap materials.

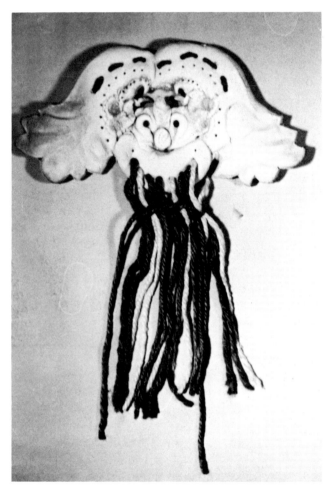

This quizzical face was sculpted in dough. After baking, colored yarns were added. Pamela Pomeroy.

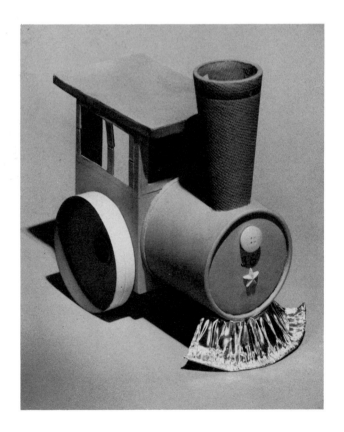

A little engine made from familiar materials. Bloomington (Ill.) High School, Elizabeth Stein, art teacher. Courtesy Arts and Activities.

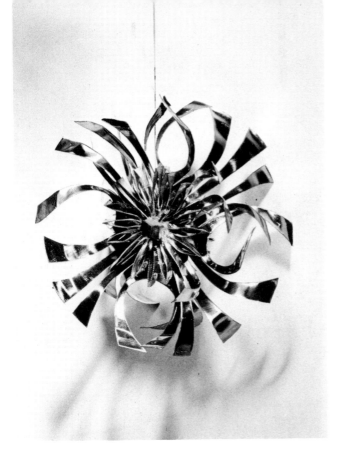

An illustration of how an unrolled can was cut to make the decorative ornament. Duck bill shears were used. The center section was cut with straight shears, folded, and cemented to the back. A large lump of colorful enamel was used as an accent in the center.

Insulation felt cut on a band saw, with the many layers glued together before careful sanding. Andover (Mass.) Academy.

Materials:

Hardboiled eggs (white), Vegetable dyes, Vinegar, Candle, Beeswax, Stylus and Cleansing tissue.

Stylus:

Use copper or aluminum foil to make the stylus and cut to shape of pattern. Roll into a cone, leaving a pin hole in the bottom. Bend over the two fins and use a fine wire to attach cone to a stick.

Procedure:

Heat cone of stylus over candle. Scrape a little beeswax into cone, warm again and use stylus as a ball-point pen to draw your design on egg. Heat wax in stylus as necessary.

Mix dye in hot water and add 1 tablespoon of vinegar. When design is complete, dip egg into dye.

Wipe off wax by heating over candle (or rolling over a hot plate) and wiping with cleansing tissue.

Eggs may be tinted lightly first, before any wax is applied, if pure white lines are not desired in the design. Successive dippings may be done as the design progresses to obtain a variety of shades in the applied design. Dry eggs thoroughly after each dipping. Young children may use a wax crayon instead of the stylus.

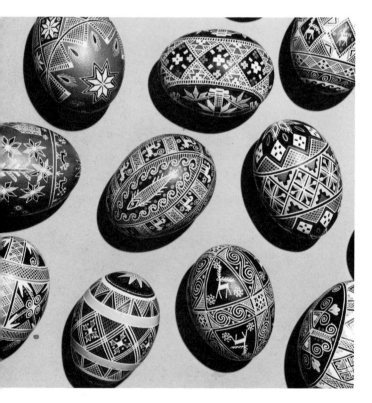

Photo courtesy of Surma, "The Ukrainian Shop," 11 East 7th Street, New York, N.Y. 10003.

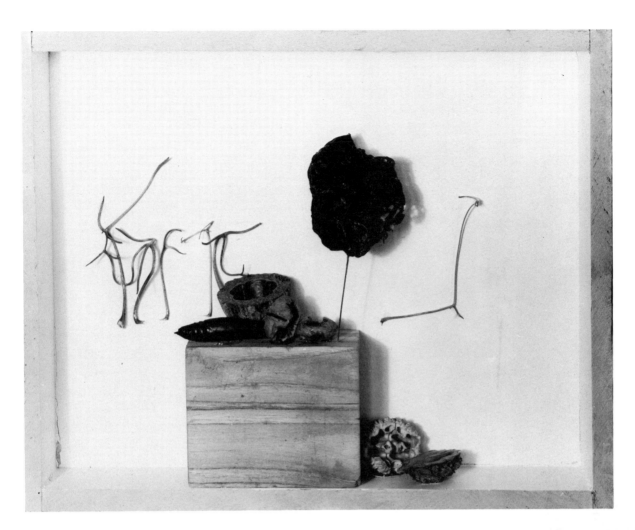

"The Things We Leave Behind" by Donald Reichert. A small box sculpture composed from shells, seed pods, chrysalis, dried apple skin and clematis tendrils. Photo courtesy of the artist.

A bird made from eggshells, pipe cleaners and drinking straws.

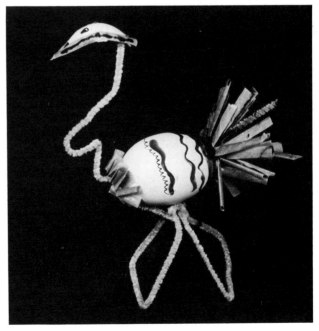

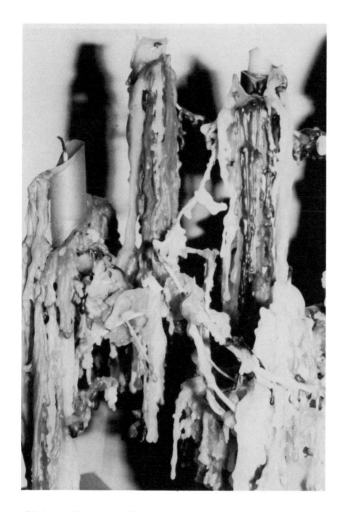

Old candles, paraffin wax and some wire make a fascinatingly eerie composition. Art teacher: Vija Hamilton, Von Tobel Junior H.S., Las Vegas, Nevada.

Wax relief sculpture made in a simple but unique way. Paraffin is the basic material. Colored wax crayons were melted with paraffin to create several different colors of molten wax. The wax was poured into a shallow box made of plywood and strips of lath. After the first color had cooled, another layer of color was poured and the process was repeated until a multi-layered wax slab was formed. When the slab hardened it was carved and textured. Interesting color, shape, and surface textures were achieved by carving to various depths into the colored layers. Shirley Hurt, Kansas State Teachers College.

Bottles often have beautiful colors and shapes. These can be enhanced by the art of bottle stretching. Using a kiln, glass can be heated to a stretchable consistency, and unique art forms can be created.

If you have a top loading kiln, drive some 1-1/4 inch screws slowly into the fire brick on the top lid. Coil copper wire around the neck of a bottle and attach the wire to a screw on the top of the kiln. Repeat the process using different kinds of bottles and different lengths of copper wire so that when the top is closed you will have bottles hanging at different heights from the top. One bottle should be visible through the kiln peephole to allow a constant watch on the process. When your kiln reaches approximately 700 degrees (kilns vary in their intensity of heat so you will have to experiment), shut off the kiln and let it cool for ten (10) to twelve (12) hours.

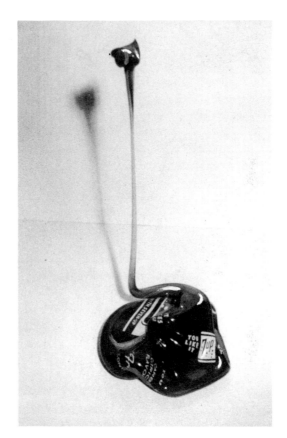

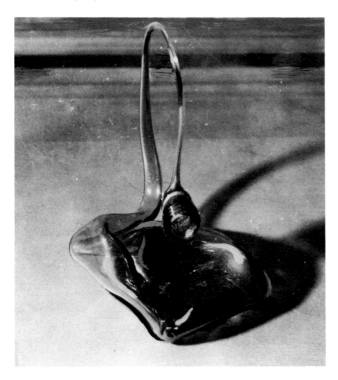

The next step is very delicate. You must be careful in opening the lid that you do not break the stretched bottles. Practice will tell you how much time to let the heated bottles cool in the kiln, as well as which bottles work most effectively for stretching. Also, the effects of letting two or more bottles fuse and the achievement of greater variety in stretched forms is learned only through experimentation.

Stretching bottles is fun. The results are pleasing. Try it. Thanks to Dan Kerkhoff and his students of Unity Junior H.S. in Milltown, Wisconsin.

collage

Collages are exciting art productions for most students — both to create and to look at, touch and enjoy. The textural quality of a collage is one of its important characteristics.

Collages became an important form of art expression in the early part of the century when Georges Braque and other cubistic painters began to create compositions with pieces of scrap materials. Later the Bauhaus helped to expand the interest in collages throughout Europe and, in turn, among artists and students in this country. The word "collage" comes from the French word "coller", meaning to paste, or to stick. Kurt Schwitters, the German artist, called his collages "Merz Pictures" — a contrived and virtually meaningless name.

We might consider collages to be textural compositions — a theme or an idea portrayed by a combination of materials. The slick, shiny surface of a magazine photo clipping provides an exciting contrast when combined with the rough texture of burlap or a piece of knitted material.

Calico, corduroy, felt, and wood on burlap. Fabrics were glued to background and stitchery was added by Laura Knowles, age 7. Sheila Warren, art teacher.

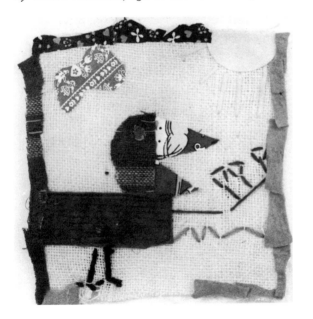

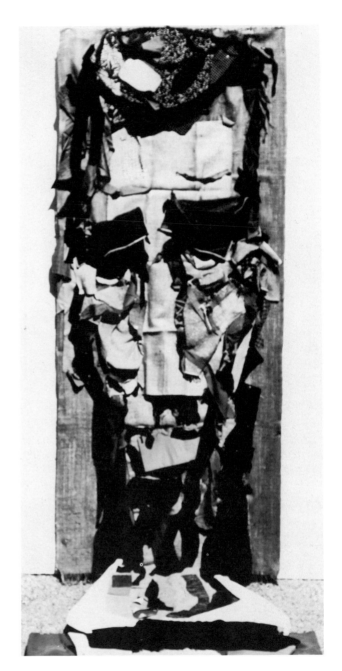

"Lincoln." An eight-foot-high portrait made of colorful scraps of cloth stapled to Celotex board which had been nailed to a wood frame. Some areas, such as the nose and cheekbones, were slightly stuffed before stapling. When on exhibition, a fifteen-foot body, made with the same materials, extended onto the gallery floor. Artist, Harry Wood, Tempe, Arizona.

*A collage made by a junior high school girl. The
theme and the materials are evident.*

Collages may be organized around a theme such as architecture or heads. Then various photos of these subjects can be clipped and combined with textured materials cut to have some relation to the theme. Or, a collage may be created that is entirely non-objective or abstract. The important factor is that the arrangement be made with aesthetic quality and sensitivity. A collage cannot be considered an art project if it is merely a collection of textured materials stuck to a background.

The use of clipped magazine pictures enables the artist to employ a wide range of colors in his compositions. These colors when carefully combined with textured materials can produce contrasting and dramatic compositions. Of course subtle colors can be used to create equally satisfying collages.

Collages or textured compositions are fun to do and they are a challenging form of art expression, calling for ingenuity and creative thinking. There are no special collage materials. It is possible to use string, paper, cotton, bark, buttons, glass or almost anything else. Collages cause almost every material to become an art material.

Colored tissue was torn and crumpled as applied. Short pieces of drinking straws were incorporated in the right cheek, and toilet tissue rolls form the left eye. Note the small photos mounted in the rolls. Susan Morgan, Fort Lee (N.J.) H.S. Joan Di Tieri, art teacher.

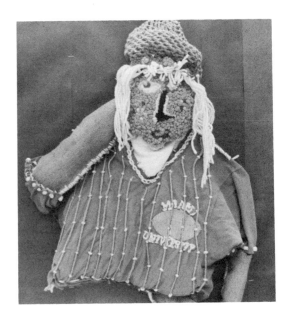

This winsome figure was made from an old T-shirt, a crocheted hat, burlap, other fabric scraps and yarn. It hangs easily with a three-dimensional feeling from hanger. Art teacher, Sharon Bollen, Marian H.S., Cincinnati, Ohio.

With any other media it would be difficult to produce a better environment for this innocent little nature boy.

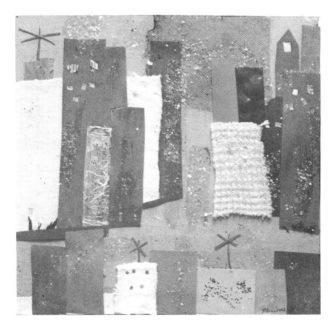

Houses are the motif for this collage made by a middle school student. Scrap materials, for projects like this, need to be sorted and stored so that they are as readily available for creativity as are paints, papers and brushes.

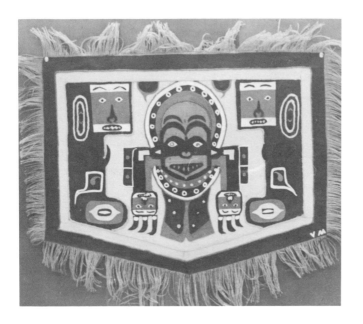

Assemblage construction. A ninth-grade, small group project. Seeds, pine cones, popcorn, string, cotton, driftwood, cloth, stones, acorns, and spools. Each student selected a box and created within it. All boxes were then mounted on a piece of plywood. Roosevelt Jr. H.S., Erie, Pa. Dan Kelleher, art teacher.

Elmer's glue was used to adhere felt and yarn to burlap backing in this piece inspired by an art student's study of the American Indians. Vicki Mannino. Art teacher, Sharon Bollen, Marian H.S., Cincinnati, Ohio.

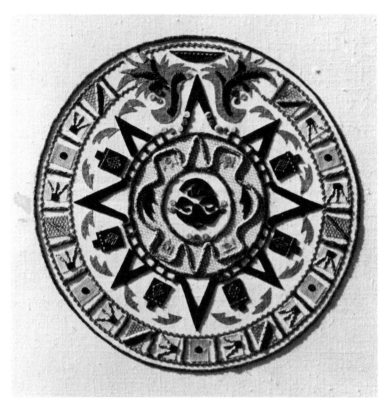

A colorful, attractive medallion made with scraps of felt, braid, yarn, net, and colored cloth glued and stitched to linen.

Bones, wood, metal gears, and paper assembled on a corkboard with epoxy cement. West Hempstead (N.Y.) H.S., Thelma Stevens, art teacher.

jewelry

Throughout history man has desired to beautify himself and his surroundings by the use of natural and man-made art forms. Primitive man wore the claws and teeth of his kill, strung necklace fashion. Anthropologists believe that this was for beauty's sake as well as for displaying his prowess in hunting. For this reason also he colored and scratched designs into his earthenware utensils, making them more beautiful to look at and more pleasing to use.

The ancient Egyptians fashioned glass enameled clay jewelry which was prized as highly then as diamonds are now treasured. Their buildings were decorated with paintings and bas-relief art work, while even their smallest utensils took on art forms suggestive of the many gods of their society. The ancient Aztecs and Mayans are remembered for their studded architecture, their feathered creations and their finely carved jewelry and utensils. Contemporary primitive tribes of Africa are noted for the great rings and ornaments of brass so expertly fashioned with the crudest of instruments. American Indians have been, and still are, envied for the exquisite jewelry and beadwork which they have created with simple tools from the natural materials indigenous to their particular area.

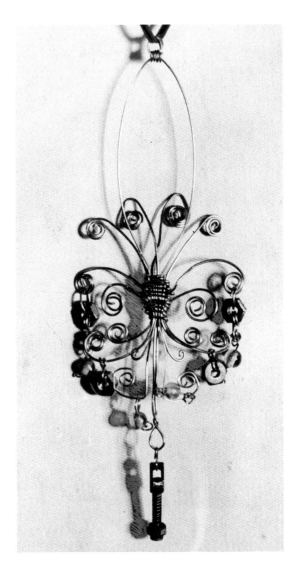

A strip of wood, pieces of felt and six small nails were used by a first-grader to make this pin.

A pendant made with only one tool. . . a pair of round nosed pliers with a wire cutter. Materials include copper wire, nuts, glass beads, and one bolt with a nut. The long strips of copper wire were joined together by wrapped wire. Beads and nuts are suspended on copper wire links. The several coils were shaped with the round nosed pliers.

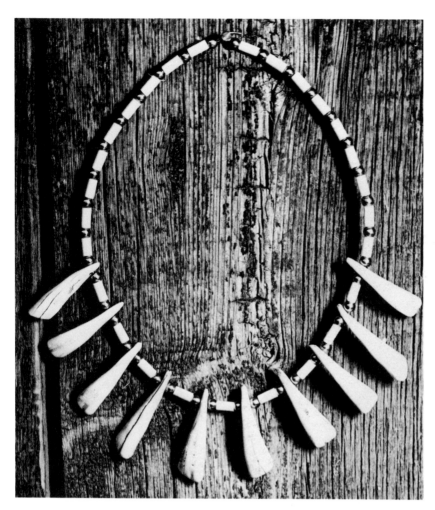

Horse teeth, long hollow bones and brass beads were combined to make this attractive Indian-like necklace by Peter Jacobs, Arizona.

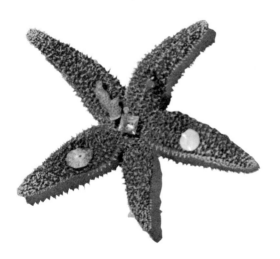

This starfish is embellished with small shells. Many indigenous materials can be shaped, colored or combined by young children to make jewelry.

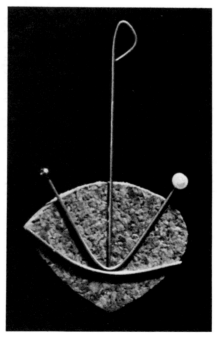

Cork, wire, and beads made this dignified pendant.

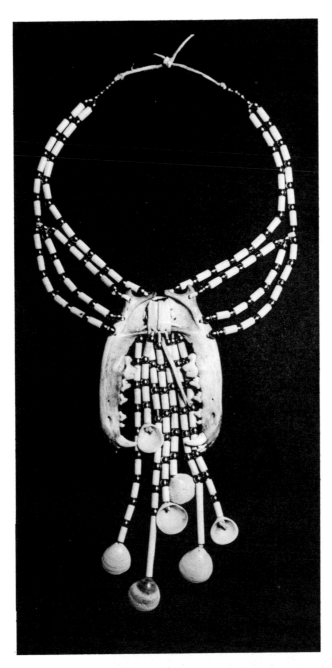

Parts of an old typewriter, wood and a piece of wire made up this very stylish jewelry.

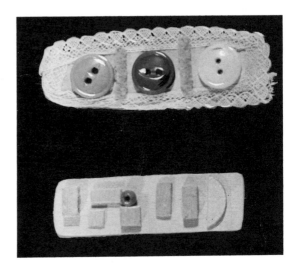

The jawbones and teeth of a coyote inspired this large pendant by Peter Jacobs. Other parts are strips of rawhide, bone and brass beads, and shells.

An interesting bar pin made by a primary grade child with a tongue depressor, lace, buttons and a safety pin cemented to the back.

In the above mentioned societies, body ornaments and craft objects were handmade and a basic part of the individual's life. Today, though it seems that modern culture is just as conscious of beautifying the individual as was the primitive, each person is no longer a producer of self adornment. Rather, individuals have become consumers of the mass produced efforts of a few people who provide them with ready-made ornamentation, utensils and jewelry. Creating and wearing jewelry seemingly has always been a basic desire in man. School art programs have not utilized this interest primarily because teachers feel that jewelry can only be created with precious stones embedded in gold or silver, using expensive tools and difficult shaping and soldering processes. Not so. It seems a pity that, at least in the jewelry area, individuals do not still enjoy creating art forms for personal adornment as a part of their way of life. It is with the hope of helping our readers, and those under their leadership, to experience this joy that this chapter on jewelry from scrap is presented here.

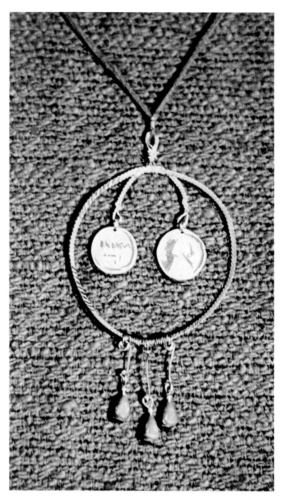

Two copper coins, a copper wire and fish line sinkers were used in this attractive pendant. Two strands of wire were held tightly in a vise while they were twisted into a solid strand with a pair of pliers. Then the twist was flattened by pounding. The two metal discs were nearly doubled in size by pounding.

Sheet copper, wire and a piece of shale.

This exquisite mosaic pin and earring set was made from tiny pieces of dyed eggshell glued to cardboard backings and then covered with clear nail polish. The pieces are reproduced actual size. This type of mosaic work has many possibilities. Try it.

A tongue depressor decorated with metal brads. Many pieces of inexpensive hardware can be used to make attractive jewelry. Try parts of old watches and clocks.

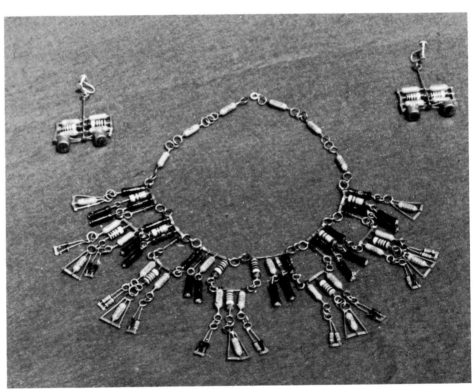

"Electronic Jewelry" from assorted condensers, diodes, resistors, and transistors. Jump rings were joined with a solder gun. Vesta Ward, Orange, Calif.

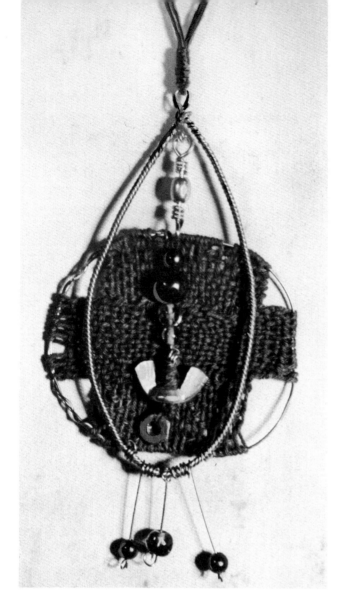

A wing nut, a fish line spinner swivel, a hexagonal nut, glass beads, copper wire, and yarn are combined in this unusual pendant. A circular copper wire warping frame for the woven background became part of the composition. The vertical and horizontal warps were woven together as they overlapped. Other parts were woven with a needle as a shuttle. By Brita.

A piece of broken bottle glass was heated enough in an enameling kiln to melt the edges and then it was wrapped in wire.

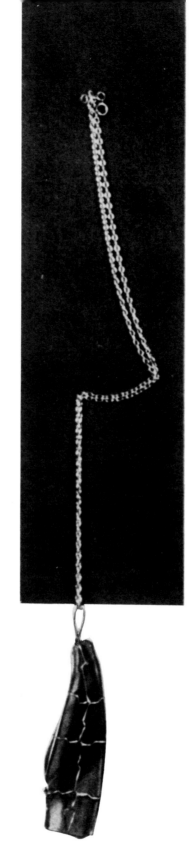

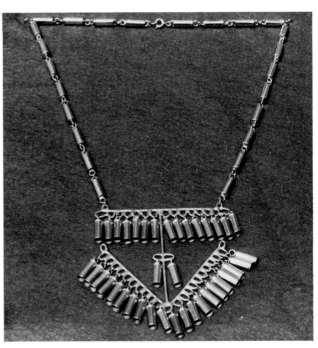

Jewelry has traditionally been thought of as being quite small and delicate, although the necklaces and breastplates of the Egyptian pharaohs certainly could not be said to be so. It is true that most jewelry is very small, at least in relation to a painting or a piece of sculpture. It is also true that if jewelry is to be an art form it must embrace the same elements of good design that are found in other art forms. When making a delicate brooch, the artist must consider it as a miniature composition and work to achieve design in it. If he plans to carve a small pendant or a kerchief ring, he must look at it as a piece of miniature sculpture and strive for the form all admire in a well done wood or stone carving. Design is an essential element of all art — large or small.

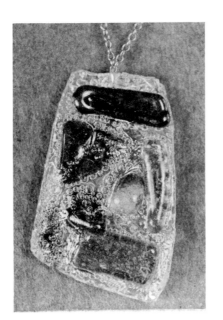

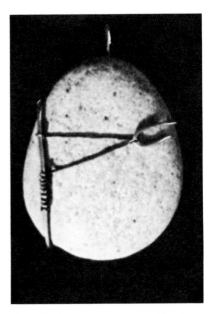

Pieces of melted, colored glass were cast in liquid plastic to shape a pendant.

A beach stone wrapped in copper wire.

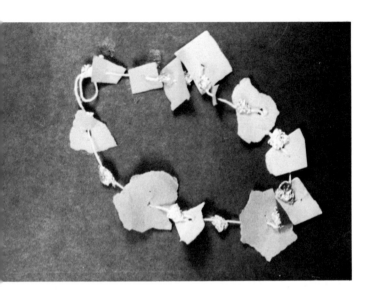

Tin foil, paper and string are the elements of this bracelet by a kindergarten child.

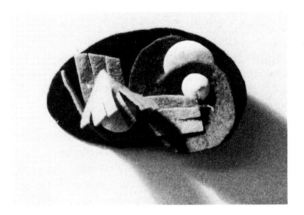

Pieces of colored felt with accent notes of plastic drops.

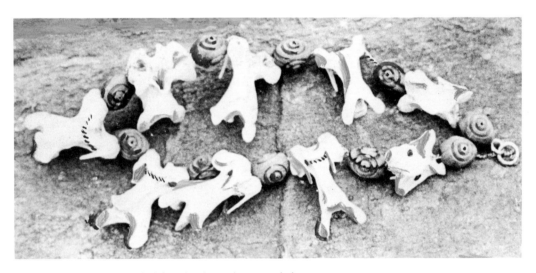

A necklace made with bleached, turkey neck bones and beads carved from olive wood. All are strung on a metal chain. Mary Campbell.

masks

To many people, a mask is a funny or hideous face that one wears to disguise himself for Halloween or a costume party. Masks have played many roles in history, and have served serious ends as well as those of frivolity and disguise with which we usually associate them.

Masks have been used by many civilizations including the primitive African, the ancient Greek, the Chinese, and even the American Indian in religious, magical, and dramatic ceremonies. Comedy and Pathos became more vivid when masks helped create the characters of ancient Greek dramas. And even today, the painted faces of the Kabuki dancers of Japan become make-up masks to establish and vivify the characters of these ancient Oriental dramas. Gods were recreated and devils rebuked by African tribesmen and other primitive societies through the use of huge brightly painted and ornamented wood and metal masks in religious rituals and ceremonial dances.

The Indian medicine man employed masks, rattles, chants and dances to chase away the evil spirits of sickness and death when famine or a scourge visited his people's village. He was not content with the powers of one mask but employed many different ones to combat the various devils and demons. The Indians, in fact, created masks to depict all phases of their life and beliefs including such characters as the village idiot, the beautiful mockingbird and even the stinging mosquito.

In modern times, many of these masks have taken on a new role as decorative wall hangings and have given impetus to a new interest in masks and their ofttimes unique simplicity and expressiveness. They have become objects of art that now are important because of their artistic and aesthetic appeal. Their true functions as symbols of deities, devils, warriors, spirit chasers and dramatic characters are now facts of the past, which serve as conversation pieces for the owner of the home they now decorate.

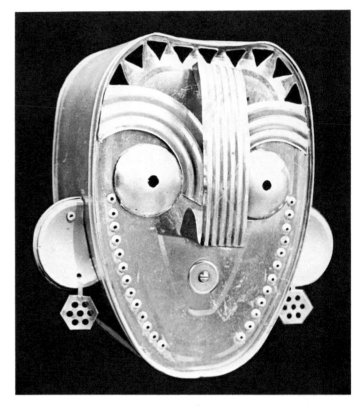

This handsome mask was made from a ten-pound ham tin. The ears and eyes are tennis ball can lids. The earrings are the perforated tops from cleaner containers. Aluminum rivets accent the mask, and repeated can opener punctures add the final touches.

A papier-mâché mask built over a form of crumpled paper. This huge mask was decorated with heavy twine glued on the surface. After being painted, the raised surfaces were brushed over with a sponge dipped in dark paint.

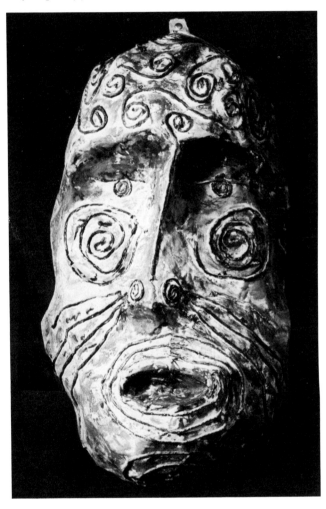

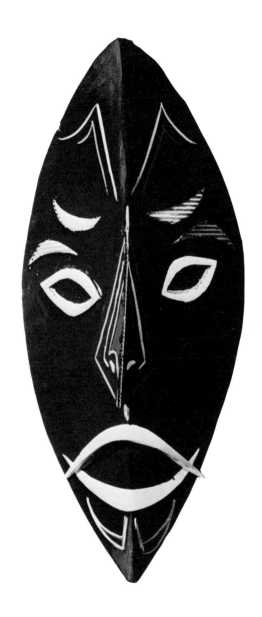

A three-foot-high mask made from a folded piece of corrugated cardboard. The face was colored black and the features were colored in white and soft pink making a very sophisticated color scheme.

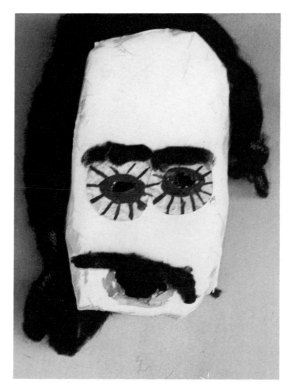

This papier-mâché mask has artificial hair, eyebrows and mustache. Art teacher, Ann Bruno, Village Meadows Elementary School, Sierra Vista, Arizona.

A mask, with colored felt and yarn, made by a first-grade child. Older children can use these same materials for more complex works.

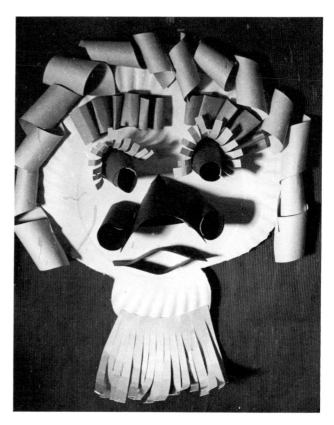

A mask of paper plates and colored papers. Craft class, A. Bonadies.

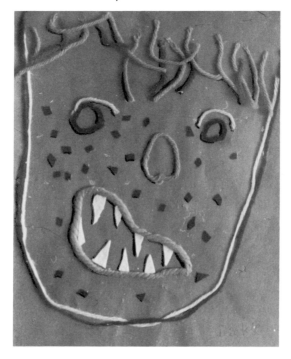

For the young mask makers, masks can serve many of the functions for which they once were specifically created. They can enhance a classroom or school drama, help to give more meaning to a history lesson, become a means of creating expressive individual characters, be designed specifically as wall hangings, or serve just as an exciting creative experience in materials and ideas developed in a mask form. Students should be encouraged to try many materials and processes in their mask making endeavors. Wood can be carved or structured; papier-mâché modeled over a screen or wire armature; paper can be cut, twisted and scored; cloth can add texture and color; and feathers, buttons, paint and brush can be used to advantage decorating and giving life to masks of the young mask makers.

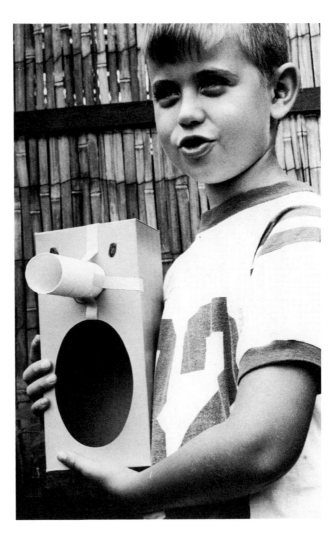

A young artist's mask created with an empty tissue paper box, a toilet tissue roll, and masking tape. Towne Photo.

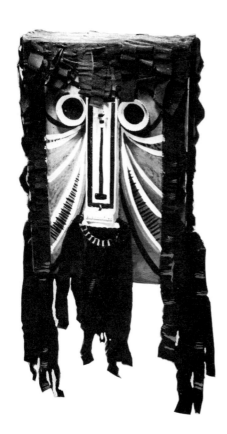

A box, crepe paper, and paint. Towne photo.

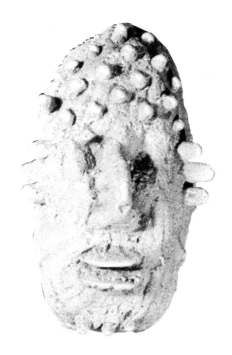

A plaster mask cast in a sandbox.

A cast plaster mask with sticks embedded in the plaster to suggest hair.

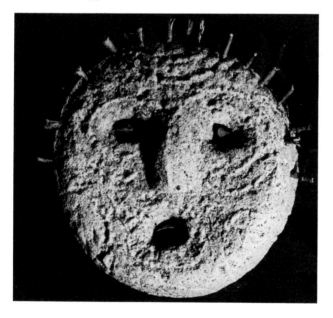

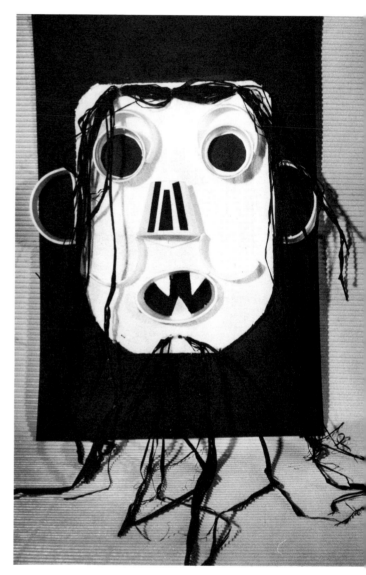

Plastic trays, cups, and raffia. Rochester City Schools.

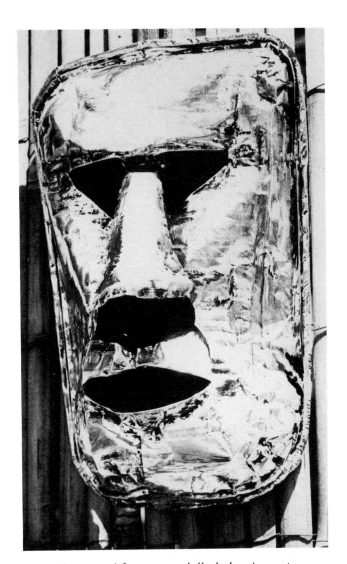

A mask created from a modelled aluminum tray. Phil Carruba.

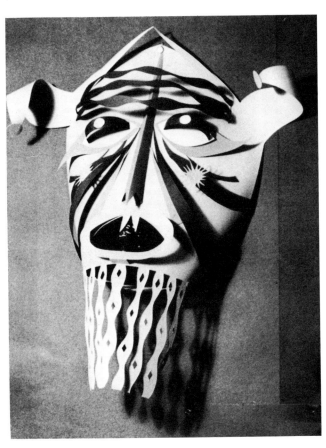

This paper mask was attractively decorated with delicately designed colored paper patterns.

mosaics

Mosaic is one of the most fascinating of the art forms. This brilliantly colored and handsomely designed two-dimensional art expression reached the height of its popularity during the Byzantine period — sixth through the ninth centuries A.D. A mosaic is a design composed of small pieces of colored glass or stone, called tesserae, set in cement. Early mosaics were fastened with a bituminous adhesive. Each tiny piece is set individually, leaving a small space between which creates the distinctive mosaic look. The designs are usually quite simple and stress the two-dimensional aspect. Large color areas take on great importance and provide the design using a flat pattern accented with sharp contours. Little or no attention is given to creating a feeling of light and shade.

Many mosaics today are created by gluing the tesserae onto a stiff backing such as Masonite or plywood with rabbit skin glue or other strong adhesive. (Duco cement and Elmer's glue are good commercially made adhesives.) Grout, a cement-like mixture, is worked into the gaps between the tesserae to provide an additional binder and also to provide the distinctive mosaic look. This latter method is the most commonly used in creating smaller mosaics and is by far the most popular mosaic technique for beginners and young students.

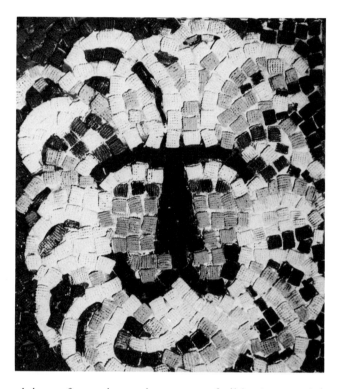

A box of cereal was the source of all basic material in this striking mosaic lion. Some pieces were sprayed black and some white. Others were left natural.

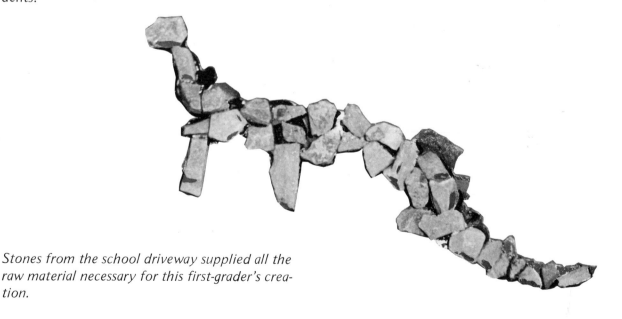

Stones from the school driveway supplied all the raw material necessary for this first-grader's creation.

Various seeds were used to develop this richly colored mosaic. A work of this size requires patience.

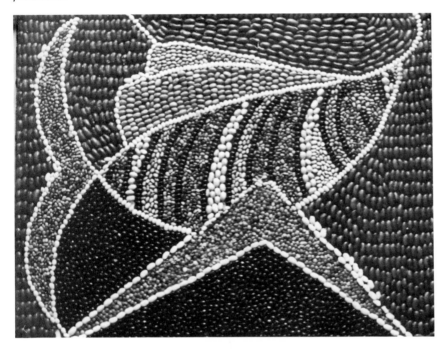

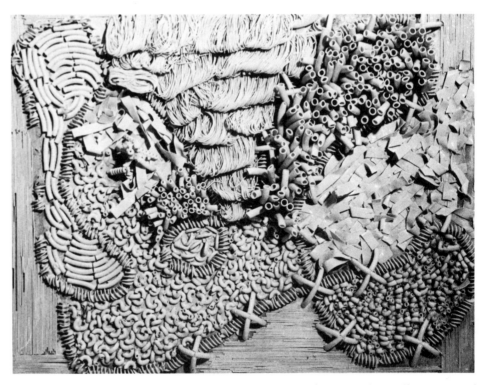

Assorted macaroni, spaghetti, and noodles arranged on a panel and then spray painted. West Hempstead (N.Y.) High School, Thelma Stevens, art teacher.

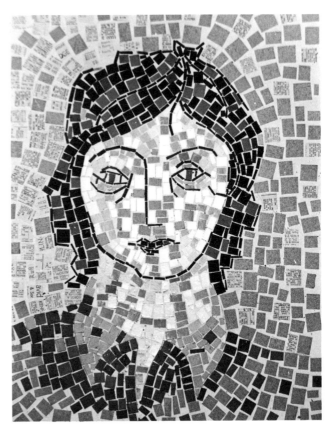

A colorful mosaic created with papers cut from magazine pages. The background has bits of newsprint scattered through it.

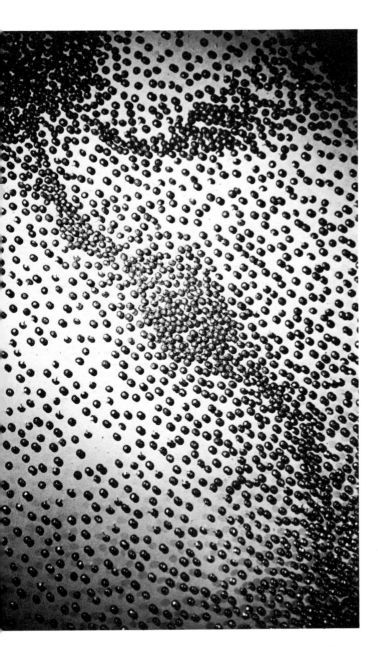

Upholstery tacks arranged in a sheet of insulation board. Andover (Mass.) Academy.

Though glass, ceramics, and bits of precious and semi-precious stones were traditionally used as tesserae, "Art From Scrap" mosaics are more interested in developing the concept of tesserae and their role in creating a mosaic. Since their role is to provide the fixture and color in a mosaic, it is necessary to discover other materials which can be used as glass was used in the early Byzantine mosaics. Materials which will provide the visual and tactile textures of a mosaic and sparkle with the color which is so characteristic of this art medium are needed. Mosaics have been successfully made of the following: colored papers, eggshells, pebbles, corn kernels, seeds, wood chips, buttons, macaroni, and even various dry breakfast cereals. These have been completed without grout. An impression of grout may be achieved through the use of colored background materials on which the tesserae are mounted, or by painting between the gaps of the tesserae with gray or other colored paint.

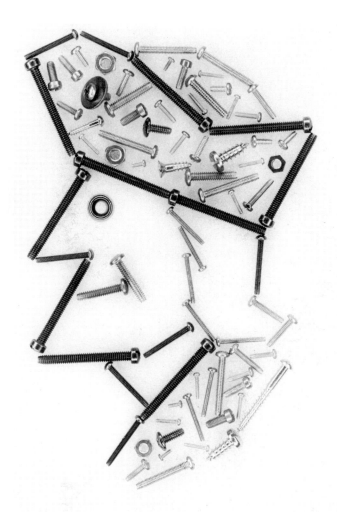

An arrangement of products produced by the Continental Screw Company.

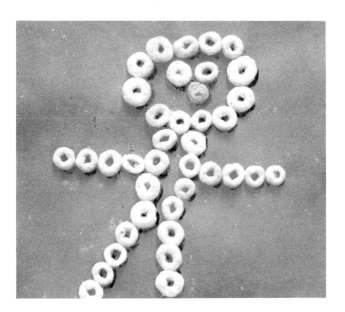

The little cereal man was made in the toasty, natural colors except for a pink nose.

In creating a mosaic, first design a simple pattern in keeping with the two-dimensional aspects of the medium. Color and texture will be created by the materials chosen as tesserae, and their use in large areas will help to promote the striking sharp line contrast, traditional in mosaic work. Making a mosaic can be an exciting adventure in design which will provide the young artist with a new challenge in technique while widening his vista in the ways and means of art expression.

Plaster sculpture cast in clay. Stones were embedded into the molded clay before casting. Aloha Camp, Fairlee, Vermont.

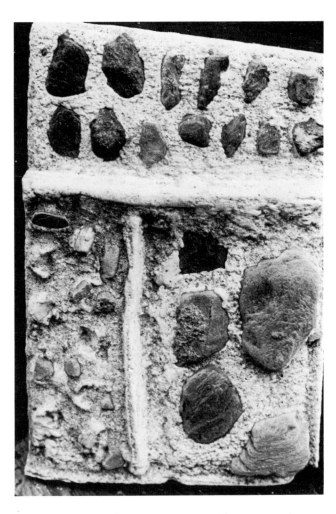

Sand casting with stones arranged in geometric patterns before casting. Aloha Camp, Fairlee, Vermont.

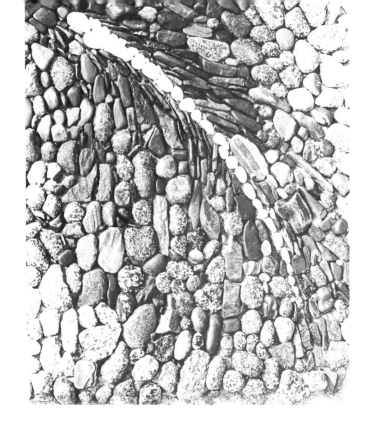

"Blast Off." A rocket ascension represented with beach stones.

"Satellites." A five- by seven-foot arrangement of stones, ranging from pure white to black, picked up on a single beach. Artist, Carl Reed, Amherst, Mass.

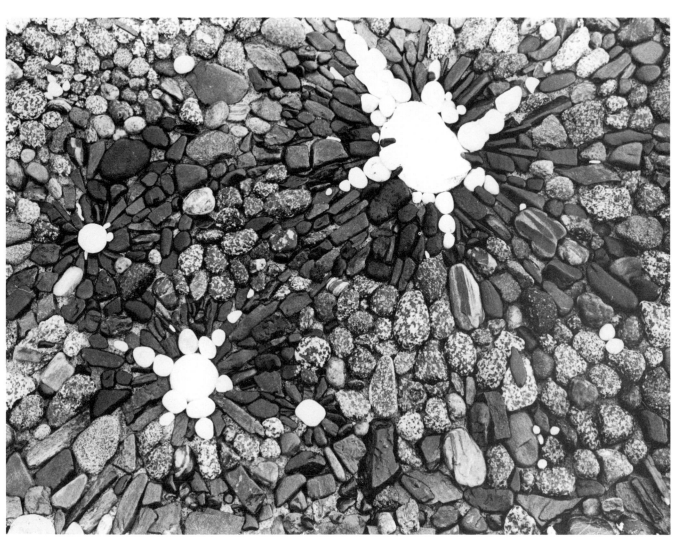

puppets

Many people call to mind only string puppets, or more correctly marionettes, when they consider this area of creative art. A puppet is actually a stand-in type of character. Everyone is familiar with puppet regimes in world politics in which the titular head of the country acts only according to the directions of the real governing powers. The puppets we make as art projects also act as stand-in characters. They represent certain people or animals and are manipulated as we desire. Just as we are free to create our own symbols to represent various things when we paint or draw, so should we be free to select our stand-in character and material when making a puppet.

Puppets have been made from the following things: an old brush, a stuffed sock and yarn, a paper bag, a piece of wood with a face painted on and a scrap paper hat, and papier-mâché with a cloth body. Also some very interesting string puppets have been made out of an old record and folded paper, steel wool and pipe cleaners, various types of macaroni strung together to make a spooky, wiggly skeleton, and tongue depressors with strings for elbow and knee joints.

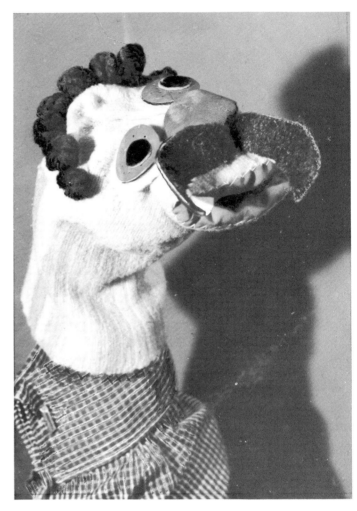

Tissue paper was used to form this sophisticated poodle.

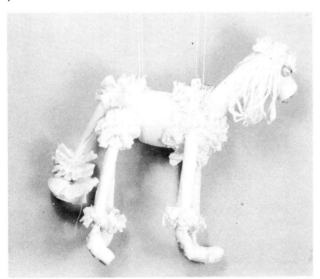

Making sock puppets provides an exciting and delightful activity for many students. The ease of manipulation and the plasticity of the face enable the forming of endless expressions. On this puppet the mouth was made by sewing red cloth over the toe of the sock. This was then folded back into the sock so that only the front edge of the red shows. The inverted toe can be gripped inside by the thumb and fingers. The facial expressions and mobility of the head are limited only by the restrictions of the movement of the operator's hand.

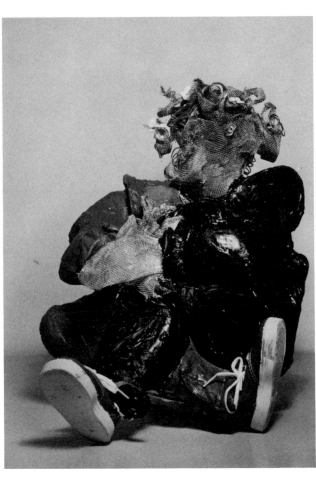

"Seated Figure with Sneakers." Wire armature, papier-mâché, screening and a pair of red sneakers painted with acrylics. Marcie Hunter, Fort Lee (N.J.) H.S., Joan Di Tieri, art teacher.

Stick puppets are fun to make and use even though they lack the mobility of hand puppets or marionettes.

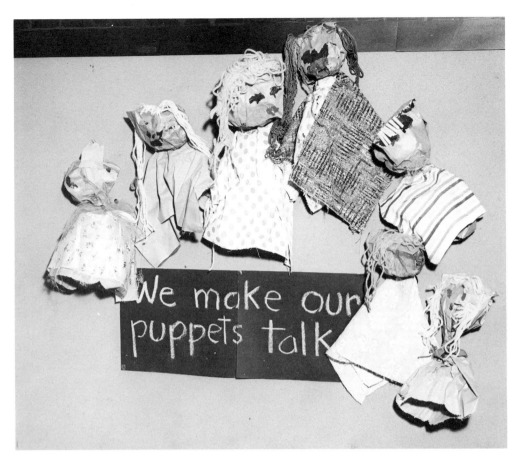

Paper bags were the basic forms with which the puppets were made by several kindergarten children. While some children chose different colors of yarn for hair, some felt no need for hair, and one child sewed on a few drinking straws. The lipstick and eye shadow are not applied as carefully as mother does, but who cares?

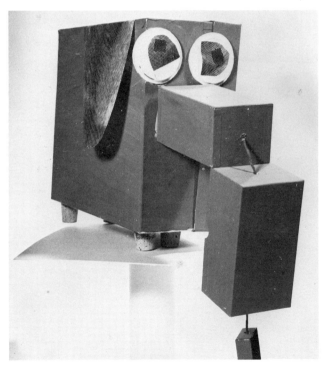

An animal puppet of boxes. Rochester City Schools.

Materials used here are evident. Towne photo.

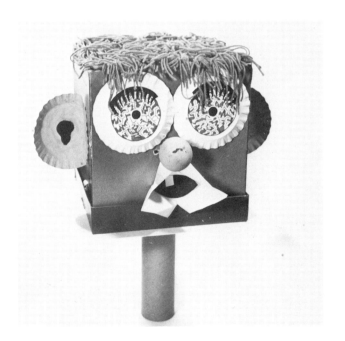

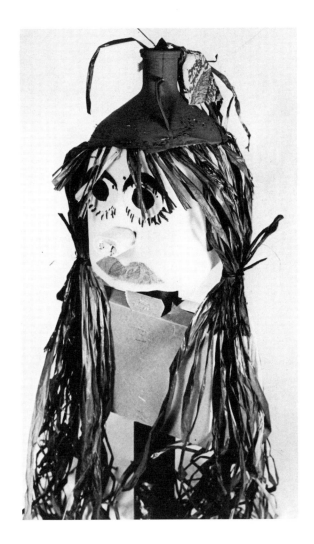

A puppet head of a plastic bottle and raffia. Rochester (N.Y.) City Schools.

Children find puppets fun to make and to play with. They provide wonderful opportunities for them to make use of many skills while working and playing with them. There are puppet plays to be written, stages that can be designed and built, costumes that need to be created and sewn, and lines that must be spoken. Making puppets also means making use of many skills such as writing, speaking, designing, building, and sewing — to mention a few. History can even be introduced through the use of puppet plays, as they once were used to spread the teachings of the church. In fact, because of this teaching use by the church in the medieval days, a type of puppet, the marionette, was given its name. During the Middle Ages the Mother Mary was the prominent figure of Christianity and so the puppet show traveled throughout the then Christian world performing with Mary in the starring role. The little string puppets were affectionately called Marionettes or little Marys by the audiences who repeatedly came to see them.

Yes, making puppets can be fun. All that is needed is an idea and a material that can soon take on a character all its own — be it a hand puppet or marionette — and can be manipulated, whether it be a bag, a sock, a string of macaroni, or an intricately carved or modeled figure.

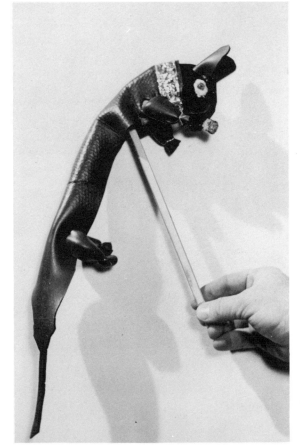

A stick puppet made with an inner tube.

weaving, stitchery and appliqué

It was not too many years ago in the history of man that all of our fabrics were made by hand. Every young girl, and some boys too, learned how to spin, weave and sew. It was essential to provide clothing, linens, draperies and all the other fabric items of one's daily existence. Today, most of this is done by machine. What handwork is done with thread goods and fabrics today is generally very specialized to complement the production of industry or a part of a growing interest in weaving, stitchery, appliqué and other forms of soft goods art that is burgeoning around the world.

The process of weaving is very simple. It has not changed significantly throughout the history of man. When a child works on a simple cardboard or nail loom, he utilizes the same approach to weaving as the great looms of our textile industry. By interlacing a woof (weft) yarn or other material through a warp (up and down) of another yarn or material, a child can weave. A machine uses the same process in simple or complex programs to weave all the many woven fabrics we use.

It is fun to weave. The process is simple and the potential materials are seemingly endless: yarns, paper, threads, straw, hair, plastics, rubber bands, wire, etc., etc., etc. Weavers today combine all sorts of materials and even weave three-dimensional creations. Try various materials in combination with others. You will have fun and what you create will have your personal signature in it.

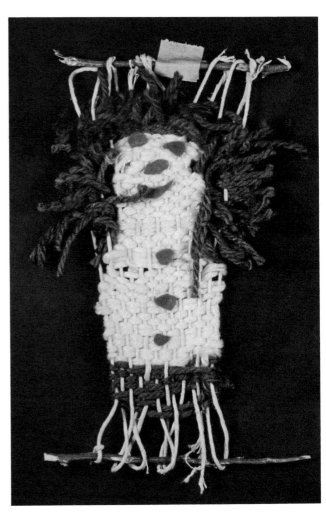

A cardboard loom was used to make this wall hanging figure. Appliqued features and buttons add character. Scott Walker, Grade 5. Art teacher, Ann Bruno, Village Meadows Elementary School, Sierra Vista, Arizona.

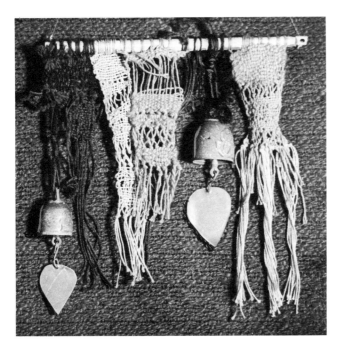

Brass bells, thin sheet brass, and yarn are combined to make this colorful and decorative wall hanging. Warp threads were suspended over the top bar and the weaving was accomplished with a needle for a shuttle. A few macramé knots were used in the center portions.

A major area of the weaving in this attractive piece was done on a small table loom. Rounded beach stones were caged by weaving, stitching, and knot tying. These add volume, color and interesting contours. By Brita.

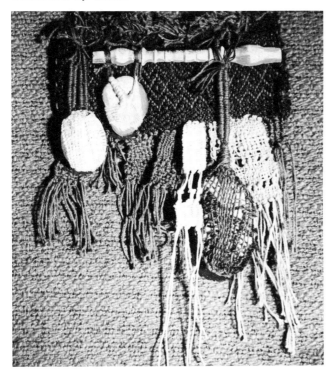

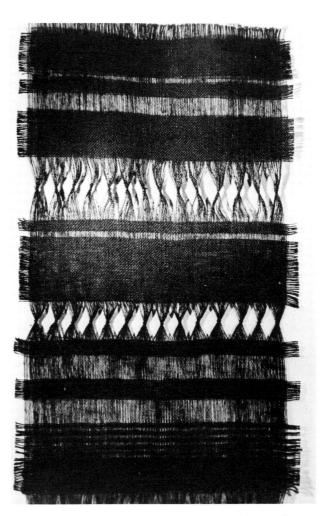

A wall hanging of black burlap created by pulling weft threads and bunching warp threads at particular areas. East Haven (Conn.) Junior H.S.

Stitchery is also a simple process. Even very young children learn how to work with a needle and thread easily and quickly. The techniques of decorative stitches are fun to learn and use, and the possibilities for creative needlework have avenues of expression for almost everyone.

Appliqué combines stitchery with woven materials. It is the application (note the derivation of the word) of decorations on fabric. A common example of appliqué is the many decorations teenagers sew onto their blue jeans. Although appliqué is traditionally done with stitchery, you will find that gluing, stapling and other forms of adhering one material to another can also be used.

Another very popular form of softgoods art today is macramé, the art of knot tying. In this book we have not dealt with macramé since there are several good books available on it. However, it should be mentioned as a craft which can involve scrap materials such as rope, thread, yarn, cord, string or rya.

A submarine sandwich made from bits of appliqued fabrics and stitchery instead of the delicatessen variety with ham and cheese. Art teacher, Sharon Bollen, Marian H.S.

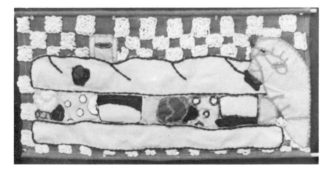

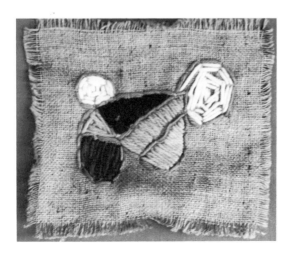

A group of fifth-grade students combined their efforts and talents to create this impressive zodiac hanging. Art teacher, Jane Miller, Sidney Fenn School, Medina, Ohio.

Burlap and yarn stitched in a colorful pattern by an elementary school child. Ed Ballard, Grade 4. Art teacher, Ann Bruno, Village Meadows Elementary School, Sierra Vista, Arizona.

list of scrap materials

Here is a list of scrap materials which can be collected and used in art projects. Of course the creative teacher and student will see opportunities for art expression in a variety of other materials also.

To make scrap material most readily available, it should be collected in advance, placed in separate containers, and indexed.

Some teachers have found that enlisting the aid of the P.T.A. in the collection activity has proved highly productive. Simply ditto a list of materials desired, distribute lists at a P.T.A. meeting, and collect at the next.

Acetate
Acorns
Aluminum foil
Aluminum pie plates
Beads
Belts
Bobby pins
Bottles
Bottle caps
Boxes
Brads
Braid
Buckram
Buckles
Buttons
Burlap
Cactus
Candles
Canvas
Cardboard rollers
Cardboard, corrugated
Cartons
Celluloid
Cellophane
Celotex
Chains
Chamois
Clay
Clothespins
Clothesline
Clock parts
Cloth
Coat hangers
Confetti
Containers
Copper sheets
Copper foil
Cord
Corks
Corn
Corn husks

Costume jewelry
Cotton
Driftwood
Egg cartons
Eggshells
Excelsior
Eyelets
Feathers
Felt
Felt hats
Fire extinguishers
Flannel
Flash bulbs
Floor coverings
Flour
Fruit jars
Fur
Gimp
Glass
Gloves
Gourds
Hatboxes
Hats
Hair pins
Inner tubes
Jars
Jewelry
Jugs
Lacing
Lampshades
Leather
Linoleum
Macaroni
Mailing tubes
Marbles
Masonite
Match sticks
Metal foil
Milk containers
Mirrors
Muslin

Meat skewers
Nails
Newspapers
Neckties
Nuts
Oilcloth
Orange sticks
Ornaments
Paper bags
Paper boxes
Paper cups
Paper doilies
Paper napkins
Paper plates
Paper towels
Paper tubes
Picture frames
Pie plates
Pine cones
Pine needles
Pins
Pipe cleaners
Plastics
Plastic bags
Pocketbooks
Popsicle sticks
Potatoes
Reeds
Ribbon
Rings
Rope
Rubber bands
Rug yarn
Sand
Sandpaper
Seashells
Sealing wax
Seed pods
Seeds
Sequins
Sheepskin

Shoelaces
Snaps
Soap
Socks
Spaghetti
Sponges
Spools
Steel wool
Steel string
Stockings
Stones
Straws
String
Sweaters
Tacks
Tape
Tiles
Tin cans
Tin foil
Toilet tissue
Tongue depressors
Toothpicks
TV dinner trays
Twine
Wallboard
Wallpaper
Wallpaper paste
Wax
Wire
Wire mesh
Wood scraps
Wooden beads
Wooden blocks
Wooden crates
Wooden dowels
Wool
Wrapping paper
Yarn

formulas and mixtures

How to mix inexpensive materials for art projects and effective methods for using prepared materials.

CARVING MATERIALS

Artificial Stone A satisfactory and inexpensive simulated stone for carving can easily be made from cement, sand, plaster of Paris, and Zonolite — a granular insulating material which can be purchased at any lumber yard.

Sand, plaster of Paris and cement should be mixed thoroughly, while dry, when used in any combination.

Mixture A: 1 part sand, 1 part cement, 3 parts Zonolite
Mixture B: 2 parts sand, 2 parts cement, 4 parts Zonolite.
Mixture C: 2 parts cement, 4 parts Zonolite
Mixture D: 1 part cement, 1 part sand, 1 part plaster of Paris, 4 parts Zonolite
Mixture E: 2 parts plaster of Paris, 1 part sand, 3 parts Zonolite

The proportions of these mixtures may be varied to produce carving materials of various textures and hardness. India ink, vegetable coloring, dry or liquid tempera may be added to the mixtures while in preparation. The dry ingredients should be thoroughly mixed in a container. Adding water should produce a thick paste-like mixture. Pour mixture into a milk carton or cardboard box and allow to harden. The cement mixtures require about three days.

Plaster of Paris Use a rather deep pan for mixing. Coat the inside of the pan with Vaseline for easy cleaning after use. Fill the pan with an amount of water about equal to the desired amount of plaster. By hand, slowly sift plaster into the water until the plaster begins to build a peak up through the water. Then begin to mix carefully to avoid bubbles. As soon as mixture thickens pour into a cardboard mold of desired size. In a few minutes the plaster will be firm and carving may begin. A little salt will speed the thickening process of the plaster and a little vinegar will slow the process.

For ease in carving thoroughly dried plaster, soak in water for a few minutes. To prevent chipping when carving, a pinch of salt and a few drops of glycerine may be added to the mixture.

Coloring may be done by adding powder tempera, liquid tempera, India ink or vegetable colors to the mixture. A marbleized effect may be obtained by adding color to the mixture just before pouring and stirring very slightly. When thoroughly dry the finished sculpture may be painted with tempera paint or oils. Shellac or a lacquer spray may be added. Clear paraffin may also be rubbed into the surface — either to the white or colored plaster.

Stonelike texture can be obtained by adding black color and sawdust to the mixture. This produces a rather hard material and is not suited to the primary grades.

Extra-soft carving material can be made from plaster by adding one part of baking soda to twenty parts of plaster. The soda causes the plaster to bubble, creating a very porous material which can be carved with ease by primary grade students.

Wax This is a readily carved material. Melt candle stumps and broken crayons, and pour into cardboard containers. If a tin can container is used the cast wax can be removed by pouring hot water over the outside of the can. (Large candles can be made this way if a wick is placed in the center of the can as the wax is poured in.)

Wax is safely melted in the top of a double boiler rather than in a pan over an open flame.

Tallow can be made into a waxlike medium for carving. This can be purchased inexpensively at any meat market. Cut the tallow into small pieces and render it. Add about 1 oz. of stearic acid for each pound of tallow. Paraffin and old candles may be added to this mixture while melted. Cast in a cardboard mold.

Wood Soft woods are easily shaped. Balsa wood is very soft and is the most readily formed by knife, saw, file or sandpaper. Clear white pine is also very easily worked.

The Southwest Indians use cottonwood roots to carve Kachina dolls. This wood is similar to the Eastern poplar tree and the Western aspen.

FIXATIVES

Art media such as chalk, charcoal, pastel and pencil need to be "fixed" if they are to be preserved and/or handled, as the media easily rub off.

Mixture A: 2 parts of denatured alcohol
1 part shellac (white)
Shake well before using

Mixture B: 1 cup warm water
2 tablespoons white mucilage
Mix thoroughly

Fixative may be applied with an insect spray gun or a mouth blow spray. Place art work on a table or floor to prevent excess spray from running. A very thin even coat is essential.

Plaster of Paris:

2 parts plaster of Paris
1 part wallpaper paste
4 parts sawdust

Mix ingredients thoroughly and then slowly add 1 to 2 cups of water. This makes a smooth mixture for modeling puppet heads.

Salt Putty:

2 parts table salt
1 part cornstarch
1 part water

Mix and then cook slowly, stirring constantly, until mixture forms a lump. As soon as it cools it is ready to model.

Sawdust:

Mixture A: 1 part flour
2 parts water

Mix flour and water and heat, while stirring until clear and thick. When cool, add fine sawdust until a thick modeling material is formed. Wallpaper paste may be used instead of flour.

Mixture B: Add sawdust to liquid glue to form a thick paste. This can be modeled or spread flat on wax paper and cut into forms like cookies. This material can be sawed, filed, whittled or sanded.

PASTES AND ADHESIVES

Airplane Glue (Ambroid or Duco cement): This glue is satisfactory for making strong joints between small pieces of material as in model making or toothpick sculpture. Place a thin coat over pieces to be fastened and allow to dry. Then apply cement and join pieces. If pieces are to be laid out flat for gluing, place them on a sheet of wax paper. The paper can be easily removed from the joint if the cement adheres to it. Commercially named MODEL cement is the fastest drying of these adhesives.

Flour Paste:

½ cup sifted flour
2 cups cold water

Add water slowly to flour making a smooth paste. Stir slowly while cooking over a low flame until clear.

Papier-mâché Paste:

1 cup flour
2 cups boiling water
2 teaspoons liquid glue
A few drops of oil of cloves

Make a creamy paste with flour and cold water. Then add boiling water and other ingredients.

Wallpaper Paste This is an inexpensive paste to use when large quantities are needed. It is excellent for use in papier-mâché. Wallpaper paste may be purchased at most hardware and paint stores. Follow the directions on the package. If the mixed paste is to be stored, add a few drops of oil of cloves and place in covered glass jars. As youngsters are often attracted by the smell of wallpaper paste and are likely to eat it — DO **NOT** USE VERMIN PROOF WALLPAPER PASTE!

Library Paste This is another good paste to use when large quantities are needed.

2 tablespoons Minute tapioca
3 tablespoons sugar
1 teaspoon vinegar
1 pinch of salt
1 cup boiling water

Mix all ingredients and cook in a double boiler until thick. It is ready for use as soon as cool. May be stored in glass jars in a cool place.

Rubber Cement Commercial rubber cement is the best adhesive for joining papers when buckling is to be avoided. For quick gluing, papers may be fastened together while the cement is still wet. For a stronger and more permanent job apply cement to both surfaces and allow to dry before placing papers together. For a really strong joint and permanency, apply 2 thin coats to each surface. When using this method, mark the position that the top piece is to take before applying cement as there is no chance of shifting once the two cemented surfaces come into contact with each other. Rubber cement can be thinned with carbon tetrachloride which can be obtained from the school chemistry laboratory. DO NOT INHALE this fluid.

MODELING MATERIALS

Clay

Native clay deposits are found in many parts of the country. This clay can be prepared for modeling and pottery.

1. Dry out small lumps of clay completely.
2. Powder it with a heavy mallet. It may be placed in a burlap bag while being pounded.
3. Sift through a ¼- or ½-inch wire mesh to remove stones and debris.
4. Sprinkle the clay powder slowly into an earthenware jar or bucket or barrel half filled with water.

5. Allow to soak thoroughly — this may take several days — and mix with the hand. This produces what is called "slip."
6. Allow slip to stand until sand settles and then pour off the slip into another container and throw away the sediment. If clay is too sandy this operation may be repeated.
7. Strain the slip through a 14 or 16 mesh sieve.
8. Allow the clay to settle and then siphon off the clear water from the top.
9. The clay may be kept moist indefinitely in plastic bags.

Cornstarch Putty

1 part cornstarch
1 part salt
1½ parts flour

Thoroughly mix above in a bowl. Slowly add warm water until a stiff dough is formed. Dry flour can be dusted on to prevent stickiness while modeling. Long rolls can be made and cut into beads. Holes for threading may be made with a nail and allowed to dry. Vegetable color may be added while the dough is being mixed. (As children are tempted to eat the dough it is safest to use vegetable coloring.)

Flour Putty This simple mixture for making small objects or modeling relief maps is composed of:

2 parts flour and
1 part salt.

Slowly add enough water to form a putty.

Gesso This fine modeling material is used to decorate small objects such as bookends and jewel boxes. Old picture frames were usually decorated with simulated carvings of gesso.

Mixture A: 1 tablespoon of gum arabic
1 teaspoon ambroid cement (Duco)
As much whiting (plaster of Paris) as can be absorbed.
Mixture B: Add whiting to shellac until creamy.

Papier-mâché Papier-mâché is a French word meaning mashed or pulped paper. It is made by adding paste to mashed paper and dried in the desired shape. It is a very light and extremely durable material. Pails, boxes and even furniture have been made from papier-mâché. It costs almost nothing and can be easily made and used by the youngest children. Its biggest disadvantage is that it shrinks considerably in drying.

Mixture A: 1. Tear newspaper into narrow strips.
2. Soak for several days in water.
3. Mash into smallest pieces possible.
4. Drain water and add wheat paste or flour to produce the consistency of soft modeling clay. Add one teaspoon of boric acid to each pint of water used for soaking to prevent mildew. A drop or two of oil

of cloves or wintergreen may be added as a preservative.

Mixture B: 1 part clay powder
1 part calcimine
2 parts water

Mix ingredients to form a thick paste. Then knead in torn pieces of toilet paper.

Mixture C: 1. Tear newspaper into long strips.
2. Dip strips in wheat paste or flour paste or library paste and place strips on prepared form making a thickness of several layers.

Mixture D: 1. Paint a coating of wallpaper paste over a sheet of newspaper.
2. Lay a sheet of newspaper on top of this and press it down firmly.
3. Paint this with a coat of paste and repeat the above process until 6 or 8 layers have been applied.

When this has become leathery hard it may be cut and molded into the desired form and allowed to harden.

PAINTS

Fabric Paint A "fast" fabric paint can be made by adding one part of powdered albumen (or egg white) to three parts of liquid tempera paint. Add a few drops of vinegar. Apply colors to the cloth freely with a stiff brush. To set the colors, place the cloth face down between 2 pieces of paper and steam with a hot iron.

Finger Paint

Mixture A: ½ cup laundry starch
1½ cup boiling water
½ cup soap flakes
1 tablespoon glycerine

Mix starch with a little cold water. Pour in boiling water. Mix in soap flakes and glycerine, and add dry powdered colors.

Mixture B: 1 pint water
4 tablespoons dry starch

Mix starch with a little water to make a paste. Boil water and add to paste and cook slowly until clear. Cool and add powdered color. Finger paint works best on coated paper. Shelf paper is an inexpensive substitute for regular finger print paper.

Oil Paints Place dry easel colors in a container and add boiled linseed oil until it is the proper consistency to paint. Keep container tightly closed to preserve oil paint. For a glossy surface add a little varnish.

Salt Stucco This paint can be used effectively to cover maps or house models. Mix one part of flour with an equal amount of salt. Add enough water to make a creamy mixture. Color may be added now or the objects covered with salt stucco may be painted a color later.

Sand Stucco A little sand may be added to mixed tempera paint when a rough texture is needed. As sand settles, the paint should be mixed with the sand in a shallow pan so that the brush can reach the bottom of the pan when dipping for paint. Sand may be added to oil paint or enamel also.

Tempera Mix dry easel colors with water to make a creamy mixture. As a binder add one tablespoon of mixed wallpaper paste to each pint of color. Liquid glue may also be used. Additional binder is necessary when tempera is used on glass or shiny surfaces. Add about 4 tablespoons of mucilage to a pint of tempera (both homemade and commercial tempera) when painting Halloween windows. CAUTION: If glass is exposed to sunlight avoid using large areas of black as black absorbs heat and causes glass to break!

This giant cardboard soldier is standing at attention and paying strict attention to his job, the lost and found man. Art teacher, Raymond Farrell, Stadley Rough School, Danbury, Connecticut.

credits

In addition to the general acknowledgments noted at the beginning of this book, and the student artists, teachers and professional artists credited throughout the book, there are several persons who must be given special mention.

Barbara Burgess, John Zichittella, and Brita took on the challenge of developing all of the prints used in the section on Graphics.

Peter Jacobs, Bob Mallary, Al Wilson and Harry Wood, all professional artists, provided numerous photos for selection. Burt Towne, and several teachers and students in the Rochester (N.Y.) City Schools supplied many photos.

Stephen Andrus of Impressions Workshop granted permission to use the print, mentioned in the text, as an introductory illustration. Printers in his shop came up with this print, in an informal competition, for use in advertising an exhibition in the Boston Public Library. Five people were involved in the design and execution of the lithograph and demonstration printing in the library. They were Lisa Mackie and Robert Townsend, Thomas Tracey, Paul Maguire, and Jean Baxter.

Arts and Activities granted permission for the use of illustrations previously printed in their magazine. Several illustrations first appeared in *School Arts Magazine*. Thanks are extended to the International Film Bureau Inc. for permission to use the title *Art from Scrap* which is the same as the title of their film on the same subject. Continental Screw Company supplied the photo using their materials.

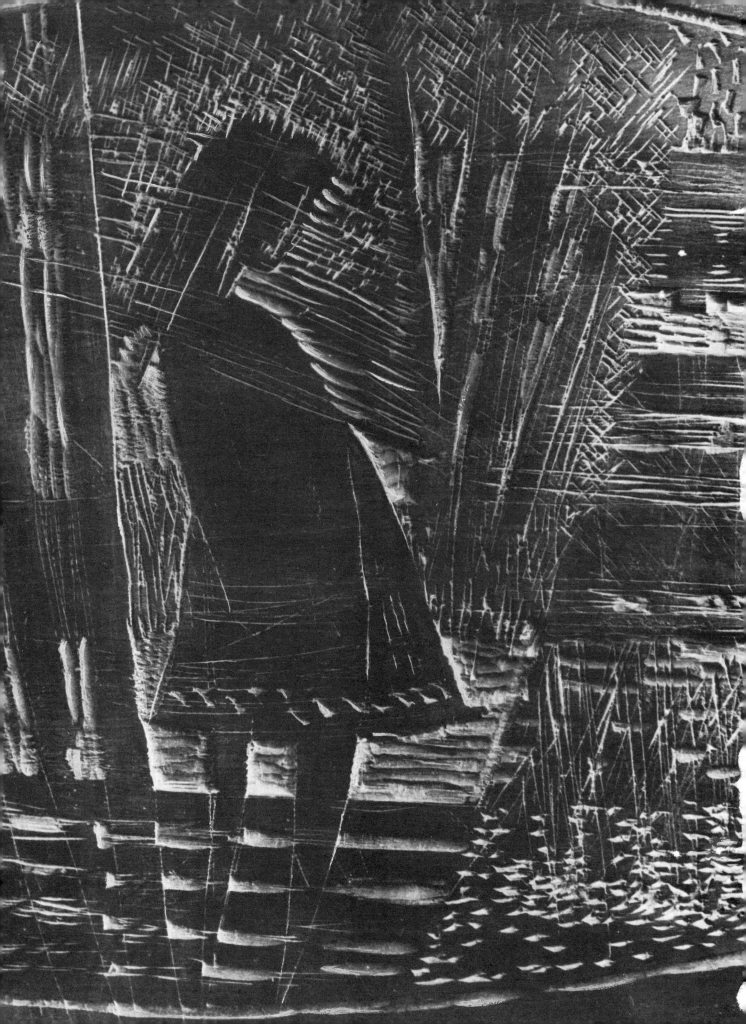